TLINGIT
Their Art Culture & Legends

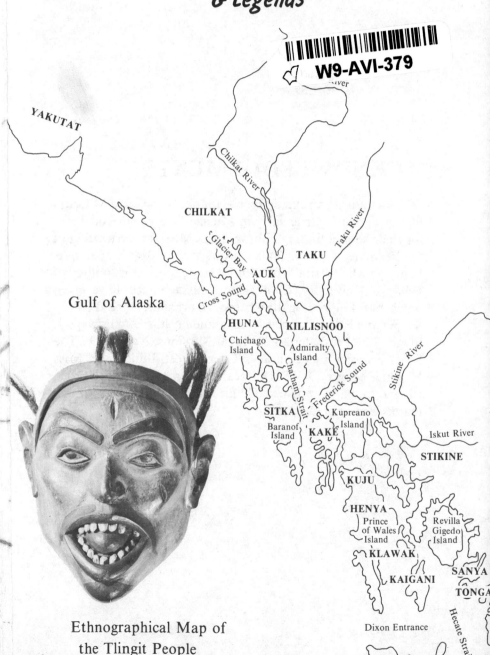

W9-AVI-379

YAKUTAT

Chilkat River

CHILKAT

Glacier Bay

Taku River

TAKU

AUK

Cross Sound

Gulf of Alaska

HUNA

KILLISNOO

Chichago Island

Admiralty Island

Chatham Strait

Stikine River

SITKA

Baranof Island

KAKE

Kupreano Island

Frederick Sound

Iskut River

STIKINE

KUJU

HENYA

Prince of Wales Island

Revilla Gigedo Island

KLAWAK

KAIGANI

SANYA

TONGA

Dixon Entrance

Hecate Strait

Queen Charlotte Island

Ethnographical Map of
the Tlingit People

This book is dedicated in loving memory of Dan.

ACKNOWLEDGEMENTS

I would like to extend special thanks to the Field Museum of Chicago and particularly to Michael Story and Ron Testa for their help in finding photographs. Miss Janet Sweeting of the Peabody Museum, Yale University, New Haven, Connecticut and Ms. Rosita Worl, Ph.D. student in anthropology of Harvard University, Cambridge, Massachusetts have given much moral support in the writing. To my sons, Donald Dixon Kaiper and Bruce Douglas Kaiper, and my husband Edward J. Slygh, The Presbyterian National Missions, New York, The River Forest Public Library, River Forest, Illinois and Miss Florence Moyer, Oak Park Local Authors Library, Oak Park, Ill. and to many unnamed Tlingit friends who helped—much thanks and appreciation.

Nan Kaiper Slygh

TLINGIT
Their Art Culture & Legends

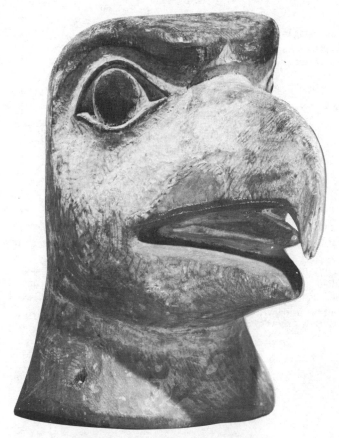

DAN & NAN KAIPER

hancock

house

ISBN 0-88839-010-6
Copyright © 1978 Nan Kaiper

Fourth printing 1997

Cataloging in Publication Data
Kaiper, Dan.
 Tlingit

 ISBN 0-88839-010-6

 1. Tlingit Indians–Social life and customs. 2. Tlingit Indians–Leg-
 ends. 3. Tlingit Indians–Art. 4. Indians of North America–North-
 west Coast of North America–Social life and customs. 5. Indians
 of North America–Legends. 6. Indians of North America–North-
 west Coast of North America–Art.
 I. Kaiper, Nan. II. Title.
 E99.T6K33 390'.09711 G78-002086-3

Published simultaneously in Canada and the United States by

HANCOCK HOUSE PUBLISHERS LTD.
19313 Zero Avenue, Surrey, B.C. V4P 1M7
(604) 538-1114 Fax (604) 538-2262

HANCOCK HOUSE PUBLISHERS
1431 Harrison Avenue, Blaine, WA 98230-5005
(604) 538-1114 Fax (604) 538-2262

CONTENTS

INTRODUCTION

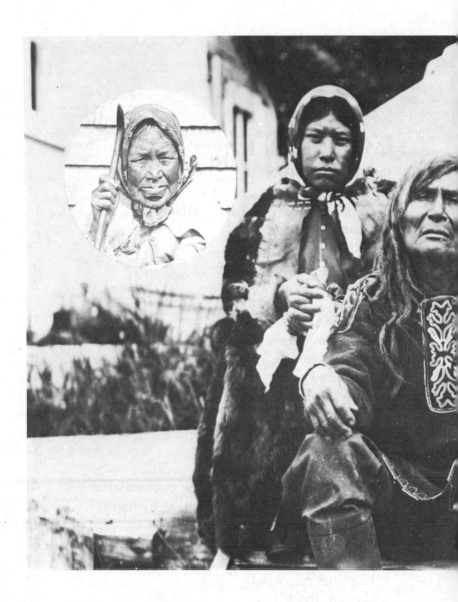

Americans who come to Alaska call the Tlingit, "natives" or "Indians." The name "Tlingit" by which the natives call themselves means the "people." Tlingit has been written many ways—"G-tinkit," "T-linkit," "Thinket." It is pronounced "Clink-it." It is estimated that

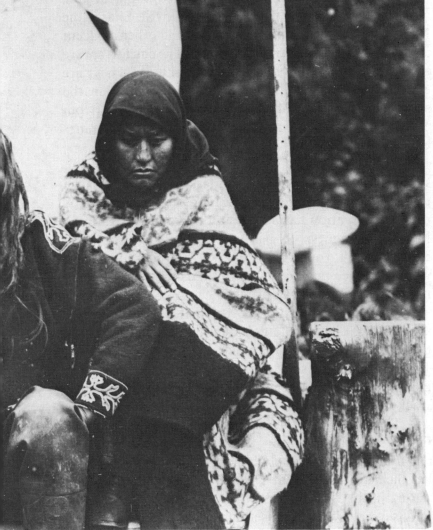

there are about 15,000 Alaskan natives today, and over half of them are Tlingits.

The Tlingits form a distinct ethnic and linguistic group of the Koluschan stock. Koluschan is from the Russian "kalyushka," meaning piece of wood (worn in the nether lip). They occupy a compact geographical area along the Pacific coast from about Mount St. Elias to the Nass River, and including Sitka and the other adjacent islands of the Alexander Archipelago. The chief tribes are the Chilcat, Sitka, Stikine and Yakutat. They are essentially a seafaring people and today work in the salmon industries. Prior to the deterioration suffered from contact with the white race they were the foremost trad - ers of the Northwest.

The Tlingit language seems to be completely isolated, showing nothing beyond the faintest verbal resemblance to the Aleut and Eskimo and the more southern Haida. A recent observation has been that it bears some affinity to Mexican tongues. It has a plural in "k," and an instrumental form in "tich" or "tsh," the combination of which produces a heaping up of final consonants, which none but the natives can produce.

Just where these people originated is a matter of speculation. Like the States Indians, they have high cheek bones, straight black hair, black eyes and swarthy skins. Their eyes do not slant, however, as do the eyes of the Eskimo and Aleut. The purer Tlingit type is short, with a stocky body and broad face.

Through legend the Tlingits claim to have been on the first Mongolian migratory wave across the Bering Strait and found openings through the glaciers which eventually led them to the Chilkat River. For the most part they settled in the island areas of southeastern Alaska, with only several exceptional settlements in the Yakatat and

Chilkat areas on the mainland. Anthropologists and explorers back in the 1880's estimated the entire population of the Tlingit to be 10,000. Demographic changes (through disease) immediately occurred when Western contact was made, decreasing the population to around 4,000. According to the old folks smallpox was the most devastating.

One of the two survivors of the smallpox epidemic that killed off a tribe of some 3,000 on Cuyu Island in just a few days was a Mrs. Tabou Clapper. She depicted the terror of it as best she could, for she was only a child. She remembered a Shaman who had come to them and told the chief that they were going to be slain by the Great Spirit because of their haughtiness and self-sufficiency. Mrs. Clapper said she distinctly remembered how the native prophet had taken a staff, which he carried, and had drawn a large cross in the sand on the shore, where the convocation was held. The sign that was to indicate the beginning of the punishment was to be the death of all the salmon that came within the proximity of Cuyu Island. Mrs. Clapper's tribesmen jeered at the Shaman and his prophecy, and the strong men drove him away.

"When the time came for the salmon run that year, the fish died by the thousands in the bay, before they could get upstream to spawn. The people were frightened, but it was too late. They were smitten by some strange disease which seemed to overtake them while they were in the very act of running away."

"I was a little girl then," Mrs. Clapper said, "and my parents took me out into the woods and left me there. After most of my tribesmen were dead, an old man found me, and put me in a canoe and took me away with him. As far as I know that old man and I were the only two survivors."

It was easy to see how such a disease could spread when

9

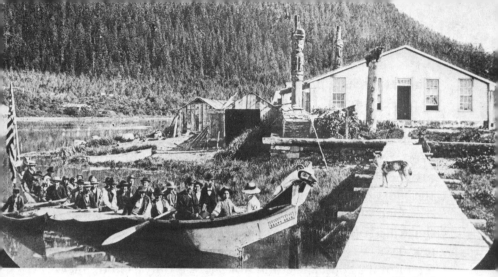

Gathering at Wrangel.

the people did not know what was causing it, or what the treatment should be. Tuberculosis, syphillis, and like maledictions were introduced by white visitors or traders, with devastating results.

The first major western contact was through the Russian settlement at Sitka, on Baranof Island. The Tlingits were hostile to the Russian settlement for a number of years, but from time to time Indian women were seduced by the white men of the colony, and thus interbreeding began. In fact, in Alaska today it is hard to find a "pure" Tlingit. The people have some Russian, English, Irish, Norwegian or American blood in their veins.

In 1867 Russia sold Alaska to the United States through the efforts of William H. Seward, Abraham Lincoln's Secretary of State, for $7,200,000.00 The odd $200,000.00 was to give clear title to the land, but Indian land rights were unsure until the "Claims Settlement Bill" was passed in 1971, ahead of the pipeline bill. The bill provides that in ten years $1 billion will be distributed to natives, some of it to individuals, but mostly to regional and village corporations in which natives will be

stockholders. Regional and village corporations will select millions of acres of lands, now held by the Federal Government, and will convey some of this to individuals, who will use it for homes, and up north for reindeer herds.

The climate of the Alexander Archipelago is mild the year round owing to the Japanese current. There is an occasional freeze which permits the children to don the ice skates, introduced by the white man, at least two or three times each winter. Because of the heavy rainfall, ranging from ninety to two hundred and twelve inches a year, the country is gloomy and wet much of the time. The dry season occurs during the months of June, July and August, and even then it rains while the sun shines. A week of fair weather actually frightens some of the natives, who go to the spruce forests in order to keep from getting sunstroke.

There are trees everywhere, chiefly spruce, hemlock, cedar and northern cypress. The alder, a deciduous tree, is also common. The country is rich in mineral deposits which are not easily located because of the rank vegetation. There is a great deal of free copper in the vicinity of Klawock. The Tlingits call this copper "tinna," and were proficient in making ornaments from it such as earrings, finger rings, bracelets, necklaces and wall hangings.

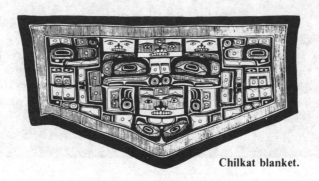

Chilkat blanket.

FOOD

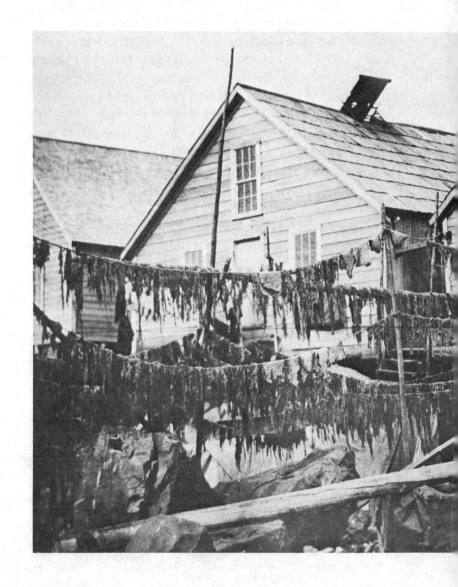

Before the white man entered their domain the staple food of the Tlingits was fish, especially salmon which were caught by the men. Women smoked and dried the salmon during the summer in quantities that would last them until the next spawning season. Since the salmon came back to

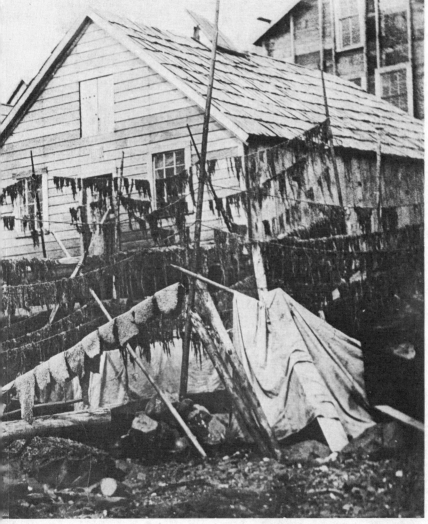

B.C. ARCHIVES

Herring eggs drying. Sitka 1889.

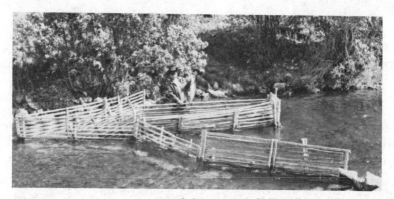

Salmon trap—Chilkat River tributary.

the same streams in which they were propagated, in cycles of every two, three or four years, the Indians were always sure of food. The salmon diet was supplemented by halibut, herring, cod, red snapper, seal, an occasional whale, crabs, abalones and clams. In fact they ate almost anything that swam the seas in their vicinity. Seaweed they dried and ate as we would peanuts. The seaweed was rich in bromine and iodine, and because of the use of this food there were no goiters among the Tlingits. Venison, bear, ptarmigan, goose, duck and other game were hunted in their season. The Tlingits were particularly fond of an oil from the candlefish or eulachon obtained by barter from the Tsimshian Indians to the south and the Haidas from Prince of Wales Island.

Another important season for the Tlingits was herring-spawning time in March. Spruce branches were put into the water along the shore. The eggs of the herring then adhered to the spruce needles which were pulled up every day or two bearing thousands and thousands of eggs. The Indians enjoyed eating these eggs raw or with eulachon oil. The eulachon or candle-fish oil is referred to as Tlingit honey.

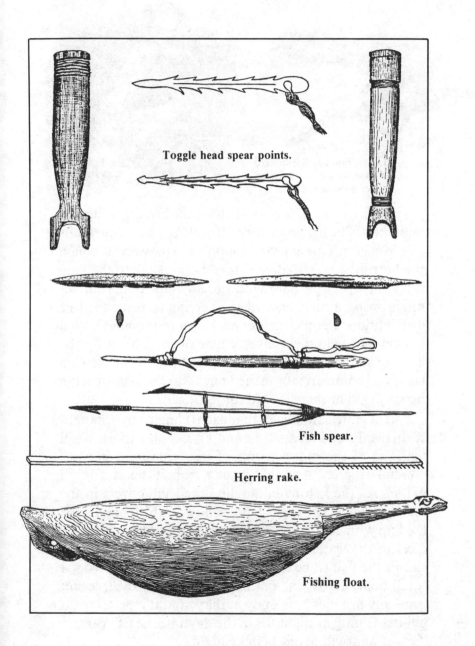

Toggle head spear points.

Fish spear.

Herring rake.

Fishing float.

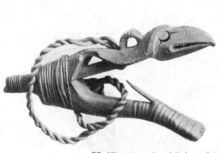

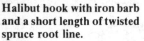

Halibut hook with iron barb
and a short length of twisted
spruce root line.

Today some of the men fish for the herring using fine
mesh nets. The herring are usually sold to a man who keeps
a herring pot. This is a wire cage hung in the water in which
the herring are kept alive before being sold to the king
salmon trollers for bait. Occasionally, one of the natives
might bring a boat load of the herring to town for free
distribution. People then come down to the boat with a
bucket and help themselves. Some of the natives fry the
herring and others salt a few down in brine. Some herring
is pickled commercially in the Tongass area but most of the
herring caught there is used for fertilizer.

It is now safe to say that each Tlingit boy is taught
seamanship and navigation and knows how to use a gill
net, one of the oldest forms of gear employed in com-
mercial fisheries. As one can guess from its name, the gill
net snares the fish by entangling their gill covers in the
mesh. The gill net is suspended downward from a rope
held up with cork floats. With the aid of sinkers, it stands
erect in the water. The size of the mesh depends on the
size of the fish to be caught, and the net is let out from a
small boat, across the path of the fish run, the free end
generally fastened to a buoy in the water. It is better to do
gill net fishing at night for in the daytime the fish can see
the net and will avoid being caught.

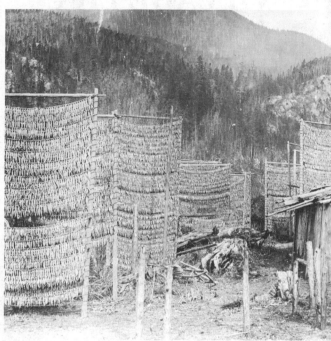

FIELD MUS. N.H. CHICAGO

Wooden salmon fishing charm. Drying eulachin.

The first salmon cannery in Alaska was located at Klawock and by 1937, there were two canneries: The Peratrovich Cannery and the Demmert Cannery. Both were owned and operated by Tlingits. Again, while the men fished, the women would get jobs for an hourly wage in the salmon canneries.

Huckleberries, salmon-berries, salal berries and thimble-berries were prolific in this area, and used as food in season. The Indian children were very fond of the shoots of the salmon-berry and wild parsnip and in the spring, usually about the middle of May, sucked on these sweet shoots as white children suck candy.

17

VILLAGE LIFE
& CEREMONIES

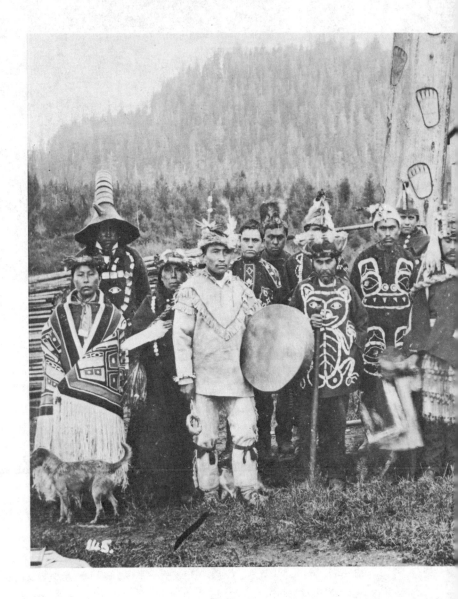

In the olden days it was the custom of the natives to gather together in villages during the winter months. They lived in community houses made of cedar logs which were built into the ground for warmth as well as greater protection from their enemies. Several hundred people

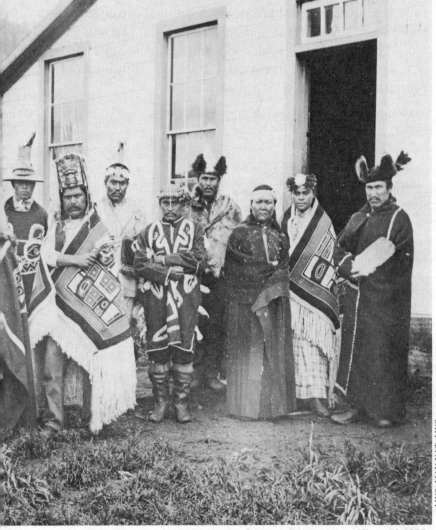

Ceremonial costumes. Wrangel 1885.

would sometimes occupy one community house, a structure of one large room. The floor of the community house was terraced to maintain the different social levels even in close proximity.

During the short winter days the men might do some hunting or fishing, make repairs on their houses or attend to repairing harpoon shafts or re-chipping sharp edges on the shell or stone knives and harpoon heads. The women would prepare meals, soak roots and rushes to soften for new baskets or gather firewood. Life was leisurely until the preparation for a feast or potlatch began.

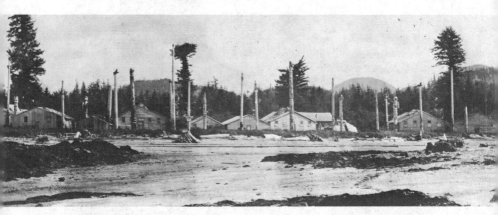

New Tongass Village.

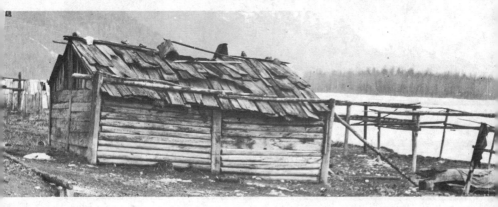

Klukan house 1902.

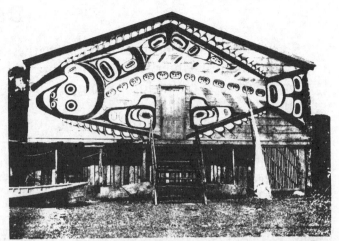

Saxman Tangass Narrows house Yakatut Bay.

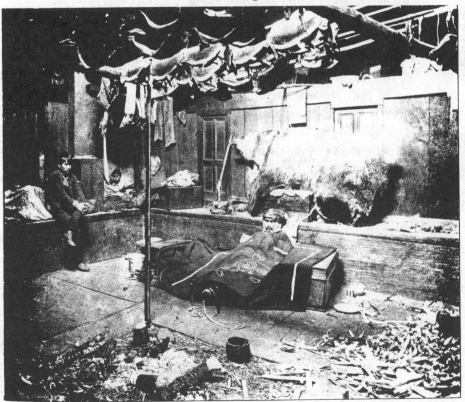

Tlingit longhouse interior.

Dance

Since summer was the main period of gathering and preserving foods, winter featured leisure time for developing arts and crafts, for feasting and dancing, and for war.

With no written record available, the learned knowledge of a people had to be passed on verbally. Therefore the history, legends, mythology and taboos were related to the young and mindful through story telling and elaborate costumed plays involving much dancing. These activities might be simple, improvised dances around the evening fire or an all-out potlatch. In any event, the Tlingit enjoy dancing, and the participants often dress as ravens, or bears, or whalekillers, or other animals of the sea or forest. The motions of the animals are imitated, and a certain combination of motions tell a particular story which is understood by the Indians. While they dance, the tribal poets and bards compose songs which they sing and recite. The only instrumental accompaniment is the drum. In such fashion the dancer can tell a personal story of how he got his crest, or perhaps make peace with his enemies and resolve any conflicts he might have with a fellow-tribesman. This is analogous to the southern Indian's custom of smoking the pipe of peace. I attended one ceremonial dance in which the dancer approached the person he had offended and went through certain motions which when interpreted to me said:

"I am sorry that I displeased you.
I shall take our trouble to the middle of the sea
And there sink it beneath the waves,
That it might be buried forever."

The Chilkat Dancers, organized in 1957 at Port Chilkoot, near Haines, Alaska have attained world

AL. DEPT. EC. DEV.

recognition and have done much to foster further interest in traditional native culture.

Today some of the dances put on by Chilkat Dancers are called: the Bear and Raven Dance, the Cannibal Giant Dance (the original totem of the Cannibal Giant is at Klukwan, home of the Chilkat Indians), the Tide Woman, based on a Haida legend, which uses several masks with moveable parts; the Fog Woman Dance, which also uses masks and is based on a Tsimpshian legend; the Ptarmigan Dance, from one of the Interior tribes; the Shaman Dance, featuring the Indian doctor making a person well. After the missionaries came this dance was used for entertainment.

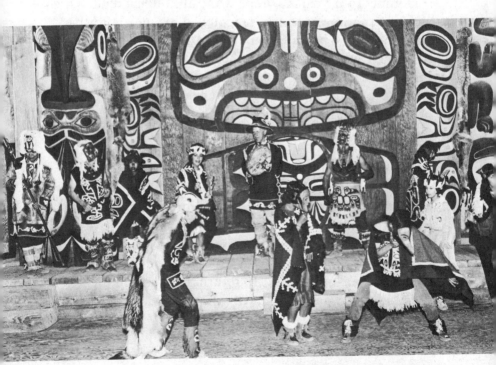

Chilkat Dances. Haines Alaska.

Potlatch

It was during the leisure winter months that most of their socializing and festive ceremonies were held. The potlatch was the most important of these. It was a feast given by a tribal chieftain or person of wealth to commemorate a marriage, or celebrate a victory, the repayment of a debt or the acquisition of a name or spirit guardian, or to re-establish friendly relations between two rivals. It was marked by feasting and dancing and storytelling, and especially the giving away of property such as blankets, canoes, slaves, fishing rights, and food. Very often the feasting and festivities might last three or four days or more. A totem pole was usually erected in commemoration of such an event. An occasion of this kind sometimes took years to prepare and although it rendered a chief temporarily poor it heightened his social prestige and renown. To be well thought of in the eyes of his fellow tribesmen was dearer to the heart of Northwest Coast Indians than untold riches. However, altruism alone wasn't the motive, for each gift given demanded the return of some future gift of greater value than the one received or humiliation and loss of face occurred. To this day the greatest harm that can befall a Tlingit Indian is to have "shame brought upon his face."

Most commonly, wealth was acquired through birth right. A good hunter, carver or shaman could also collect wealth through his efforts and craftsmanship. Relatives of lower social status and slaves were obliged to contribute to the wealth of their chiefs and superiors and by doing so incurred their indebtness. In return, they gained greater social status by association with the chief who was giving the potlatch.

Commemorative pole at Saxman showing figure wearing four ringed hat indicating owner has given four potlatches.

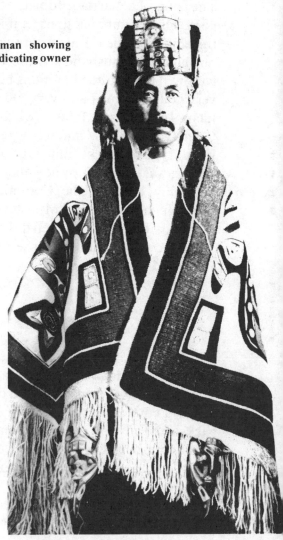

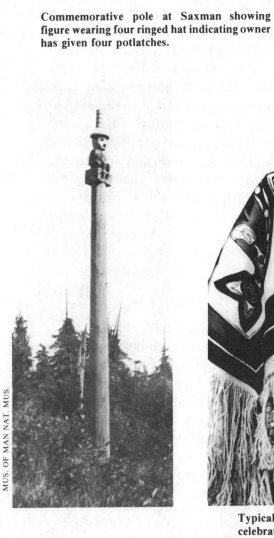

Typical chiefs' ceremonial dress for potlatch celebration.

Marriage

The Tlingits are divided into two great divisions: the Eagles and the Ravens. This division was observed by all tribes. It was a device to keep the people from inbreeding. A Raven must always marry an Eagle, never a Raven. The child of a marriage took the tribe of its mother. That is, in this matriarchial lineage, if the mother was a Raven the child became a Raven. In the event of the death of a husband, the husband's nearest male kin married the widow. This resulted in unions between very old men and very young women and very old women and very young men. In the late 1800's, with the advent of a U.S. Commissioner, the Indians were required to undergo at least a government marriage ceremony. The church service was optional. When one native was asked why he had only gone to the Commissioner and not to the minister he replied: "Minister marry me for good. Commissioner charge seven dollars and marry me today. Tomorrow I give he another seven dollars and I no longer married."

Burial

The Tlingits used to burn their dead along with their possessions: valuable blankets, carved halibut hooks, fish clubs and spears. For those who could afford it, the ashes of the cremated were placed in a niche carved into the back and top of a special totem pole. The white man introduced burial, which is the custom today. The Dead Feast is still observed, however. After the deceased has been mourned by professional mourners, a feast is given by the immediate relations of the departed one. At such a feast the virtues of the dead are extolled while everybody

makes merry. For the Tlingits to die is to pass into a fuller life and is something to be happy over.

Tlingits used to practise cremation exclusively. A lot of dry wood was placed in a pile on the beach. The corpse was placed on the wood, and green branches put over the body. With appropriate chanting and mourning a fire was lit to the dry wood and the body was burned in the sight of all the people. Many times the bereaved wife, or father, or mother, would be so overcome with emotion, that they would try to throw themselves into the fire. The missionaries rebelled against this and the practice was stopped. Today burial or a less exuberant cremation ceremony occurs.

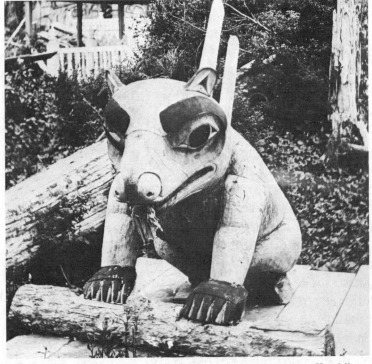

FIELD MUS. N.H. CHICAGO

Grave marker. Ketchikan.

Shamanism

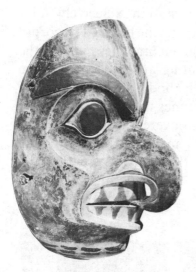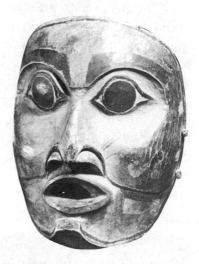

Shaman hawk spirit mask. Shaman man spirit mask.

One of the great strengths of the Tlingit was that everyone in the society had some part in it and, therefore, could enjoy and understand it. Each person had a position which gave him a specific relationship to those above him and those below him. Even the slaves, captured in war or taken in trade or born into slavery, "belonged" and had responsibilities and privileges that were shared as part of everyday living. A woman could even extricate herself from slavery by marrying a free man; a man by valor or some act of unusual courage. These social rules, moral codes and taboos were strictly adhered to and any departure from these standards usually meant severe ostracism or death. The ethic underlying these moral codes was "an eye for an eye and a tooth for a tooth."

Shaman performing rights.

Chilkat Shaman witch spirit wand.

Shaman's rattle.

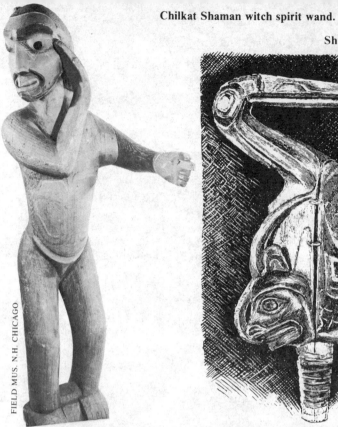

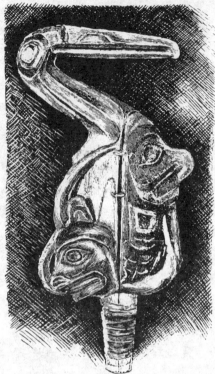

Chapel at Metlakatla.

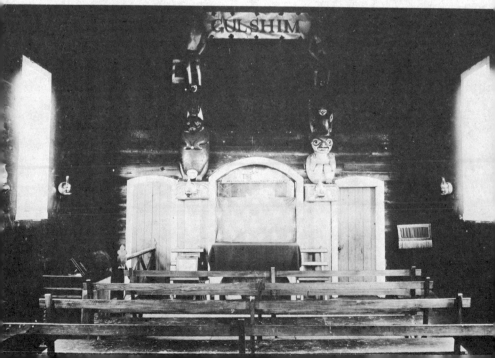

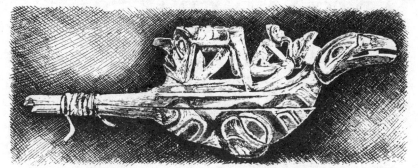

Shaman or Medicine Man rattle.

The individual's need of explanations for worldly events together with the need for strict laws led to the foundation of a dogma based on spiritualism, witchcraft and medicine.

The shaman or medicine men were people of high status. Healing methods involved both herbal remedies and magical rites. Their success depended largely upon the cooperation and personal faith of the patient.

Wearing special necklaces, robes and masks, and shaking ornate rattles, chanting and even dancing around the patient, the shaman sought to exorcise or placate bad spirits, the cause of most ailments. If successful, the shaman would receive a fee of so many otter skins or baskets of clams, the payment being related to the difficulty of the cure.

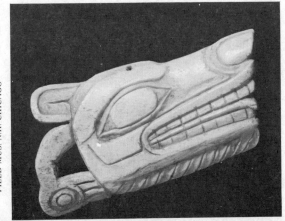

Shaman bone healing charm — probably wolf spirit.

ARTS AND CRAFTS

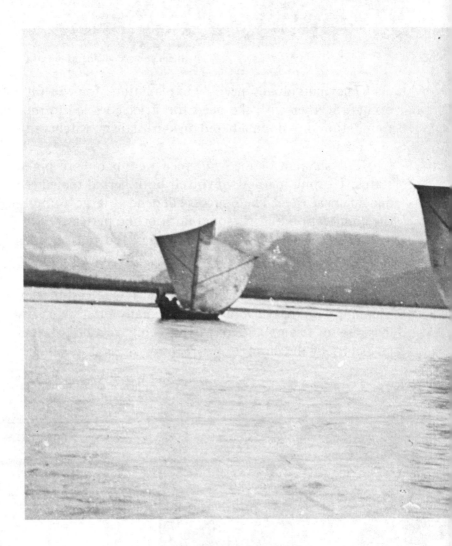

Canoes and Totems

The Tlingits were originally expert stone carvers, copper workers, wood workers, weavers and basket makers, but such crafts are now rapidly disappearing. The men made dugout canoes out of red cedar. The large seagoing war canoes were up to fifty feet long and able to

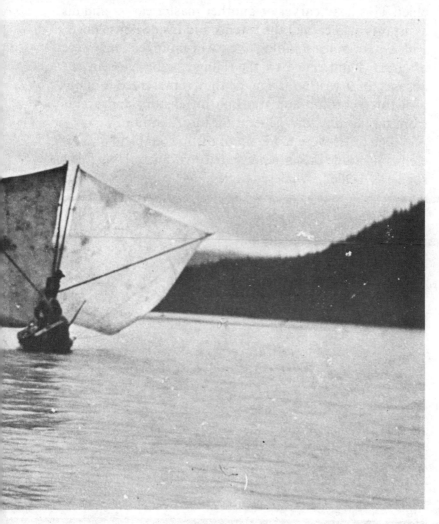

carry forty or fifty men. The prow of the war canoe was usually adorned with tribal insignia. Smaller eight to twenty foot canoes were used for utilitarian purposes such as hunting and fishing.

While many village men were involved in the total building of a canoe, the job was supervised by the master carver —a renowned individual, sometimes even a village chief. This head carver or another master carver and his assistants also carved the totems and inside house posts.

Totem poles standing twenty or more feet high were of great significance to the Tlinget tribes, for in the absence of a written language they represented a major tool for recording and transmitting history and events from day to day and generation to generation.

The poles were made up of distinct emblem or crest elements. Some crests represented real animals or items such as killer whales, eagles or coppers. Others

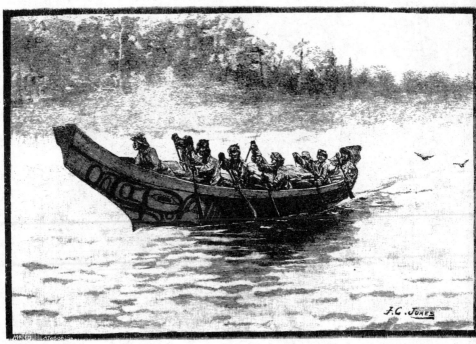

Ocean-going canoe for trading or war.

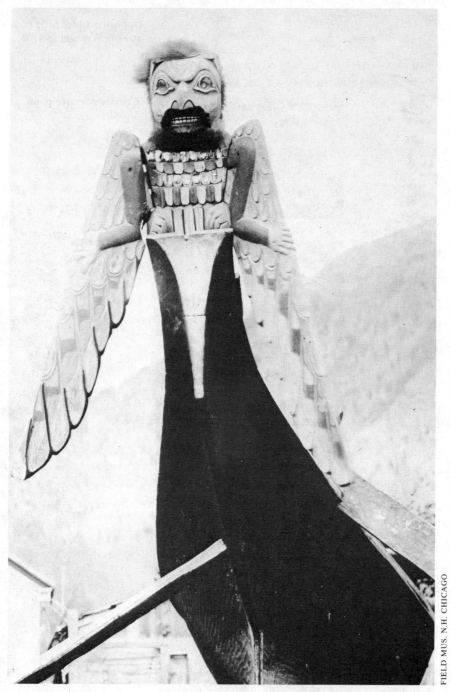

Canoe bow decoration Klukwan potlatch.

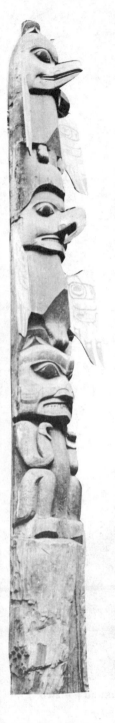

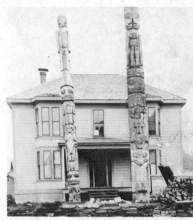

Opposite: Chief Shakes' house at Fort Wrangel in 1901.

Commemorative poles.

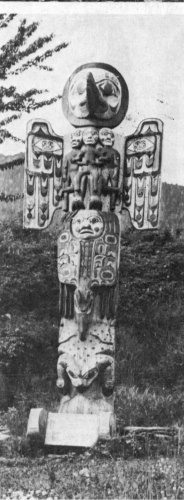

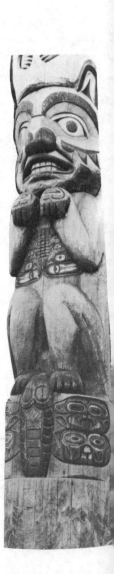

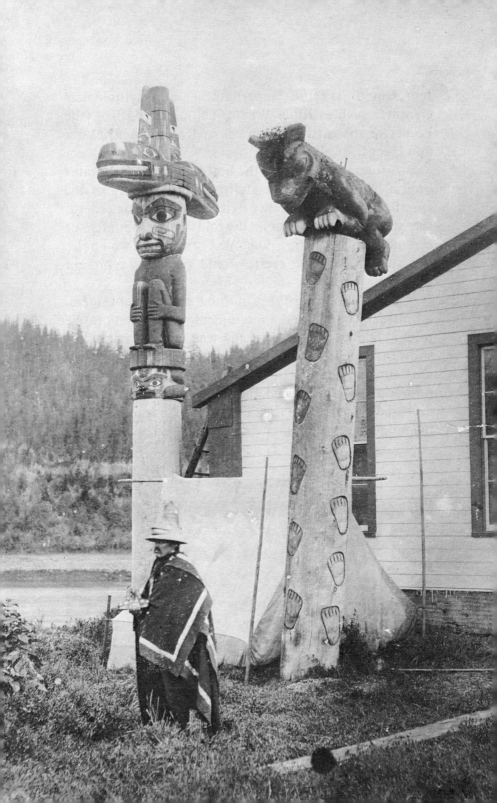

represented specific supernatural or mythological creatures such as Killer Whale, Thunderbird, Frog (the keeper of the earth's treasures) or Raven (the trickster and creator of all things).

A totem is read from the bottom up, but it contains only a list of crests, not a story. The meaning of the specific crests and why they exist in a particular order is the story that was originally told at the potlatch or ceremony when the pole was raised. Two poles containing the same crests would probably represent different stories.

There were three types of totem poles: a debt totem, a mortuary totem, and a monument or commemorative totem. The least expensive one was the pole carved to show that one tribe or person owed another a debt. When the debt was paid, the pole was destroyed. The mortuary or burial pole contained the cremated remains of the deceased stored at the top. The most elaborate pole was the monument or potlatch pole raised to commemorate a

Ketchikan pole.

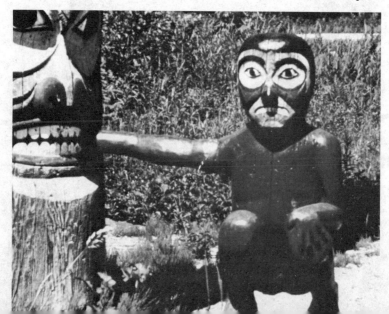

special occasion such as a wedding, a great battle, acquisition of a new guardian spirit, song, or crest.

When the Indians abandoned their old villages to live in towns or go "below" to the United States, many of the large outside totems, exposed to the elements, deteriorated. In the 1940's under the supervision of the Forest Service, the totem poles were restored or duplicated for exhibit at Saxman, New Kasaan, Wrangell, Sitka, and on the school ground of Klawock, Alaska. The totems of Klawock were brought from the deserted village of Tuxekan. As in the old days the Tlingit children again learn about their history and customs from the poles.

Some of the early missionaries thought the totem poles were idols and religious symbols and did not encourage the carvers, but today groups of natives carve with modern tools and color the new totems with natural vegetable and mineral paints, according to age-old techniques.

Long house where entrance is made through pole.

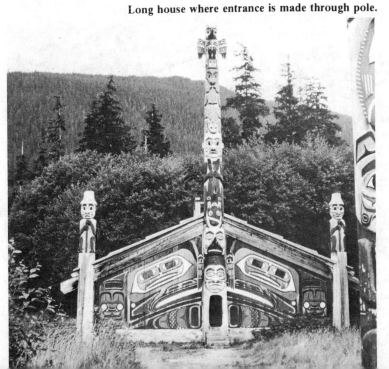

Miscellaneous Carvings

Boxes for storing food and ceremonial dress and masks were often elaborately carved and painted. The four sides of such a box were made out of one uncut board so as to produce only one seam. They steamed these boards to bend them. Steam was produced by dropping hot rocks into water.

Rattles, fishing hooks and floats, woodworking tools—practically every tool or item of use—was intricately carved. Hunting knives and spear points were carefully chipped and ground from rocks or shells. Special labrets or lip plugs were carved from wood, bone or shell and as a sign of beauty in women, were inserted through a cut in the lower lip. Wooden food and feast bowls and grease dishes were handsomely carved in the form of a beaver or seal. Ladles and spoons were of mountain goat horn or wood.

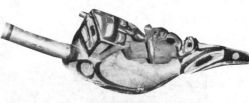

Raven rattle.

Headdress ornament with shell and brass trimmings.

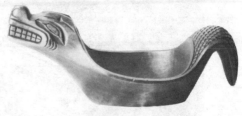

Beaver dish.

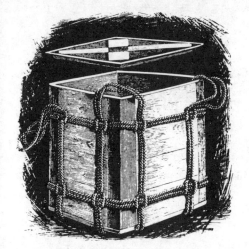

Wooden travelling chest.

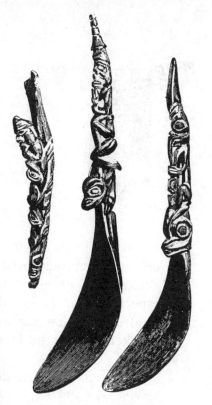

Spoons carved from Mountain goat horn.

Silver bracelet—recent.

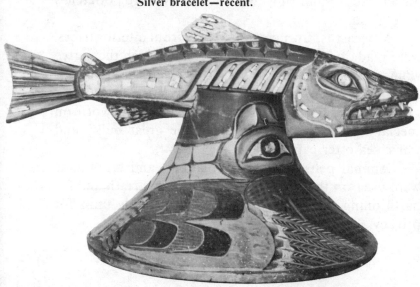

Salmon Headdress.

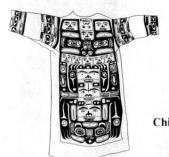

Chilkat shirt and apron.

Clothing

The Tlingit originally wore little or no clothing. In cold weather they used blankets made of goats wool. These were obtained from the Chilkat tribe, known especially for its excellence in blanket weaving. The Hudson Bay Company found a fertile field for the sale of blankets among the Tlingits, with whom they traded for furs.

For special occasions, women had wrap-around skirts carefully twined of cedar bark, with a cape to match, sometimes edged in fur from the sea otter. Hats were woven of spruce roots with basketry rings on the crown, denoting the number of potlatches given by the. owner. Additional rings were added as more potlatches were given.

Moccasins, an item borrowed from interior tribes, were made from sealskin and deerskin which the native women tanned on frames constructed for that purpose. Deer sinews were used as thread.

Intricately woven Chilkat blankets were worn on special festive occasions as were the great bulky and warm sea otter capes.

Animal pelts and woven blankets and grass mats were used on the beds for comfort and warmth and for partitioning the large longhouses into family units for privacy.

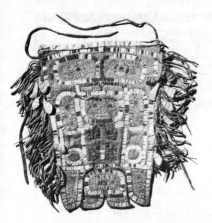

Quilled leggings.

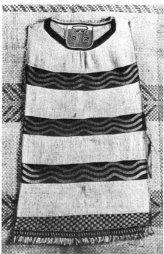

Chilkat goat wool jumper.

Typical Tlingit ceremonial chief's costume.

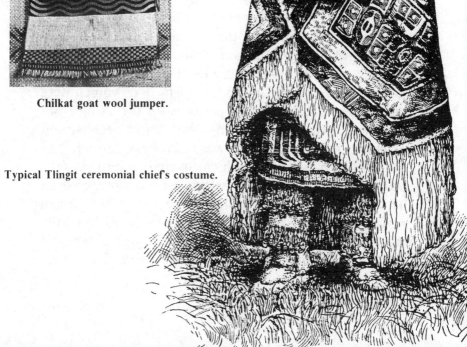

Basketry
and Weaving

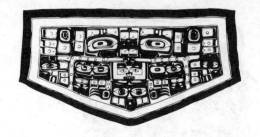

From locally available grasses and roots different fibers were collected for basket making. Coarsely woven, open twined baskets were used for carrying clams and roots while others were so tightly woven that they were waterproof. Hot stones were dropped in these to boil the water and cook the contents. Because pottery was entirely unknown to the Northwest tribes, basketry containers were utilized for most food cooking and storage.

Coarse mats woven from strips of cedar bark served many purposes. The juices of berries, and some minerals and urine were used for coloring.

The Chilkat tribes were famous for their intricate and valued woven blankets. These prized Chilkat blankets were traded to the nobility of all Northwest Coast tribes. The patterns were designed by men who were the only ones allowed to know the stories behind the superstitious and mythological crests. The women were then allowed to weave the patterns on their single bar warp-weighted looms, using two and three strand twining. The stronger warp was cedar bark covered with goat wool while the weft, which covered both sides of the warp, was only goat wool; either natural white or dyed black, bluish-green or yellow. The abstracted design represented real or mythological figures used in family crests. It often took a woman an entire year to weave a single blanket which utilized all the wool from three goats.

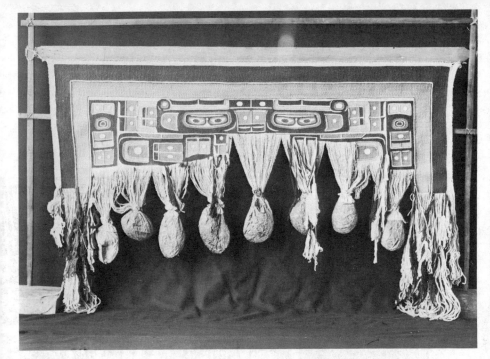

Chilkat blanket being woven.

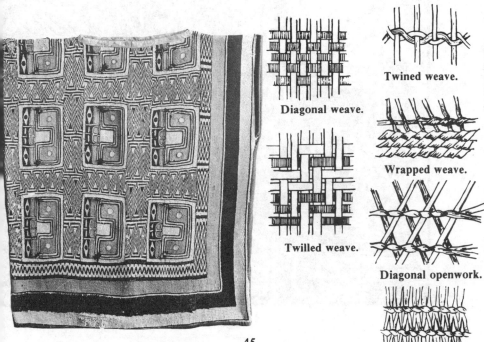

Chilkat goat wool poncho.

Diagonal weave.

Twined weave.

Twilled weave.

Wrapped weave.

Diagonal openwork.

Plain openwork.

45

LEGENDS

Because there was no written language, the passing of accumulated knowledge, social customs and history from one generation to another rested upon oral traditions of story-telling and enactment of legends. The following legends were told to Dan Kaiper in the late thirties.

Chief Shakes lying in state.

Legend of Creation

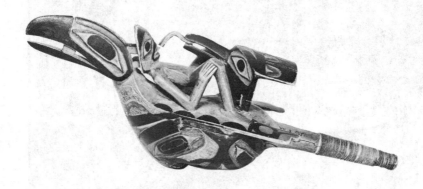

We have two stories of creation in the book of Genesis of our Holy Bible and the Tlingits have two stories of creation. The story we will tell you gives the credit of creating the earth to Raven. The raven is revered by the Tlingit and their hunters will not shoot these big black birds that have human voices.

As one woman said to us: "Klawock is only a croak in a raven's throat." I asked: "What do you mean by that?" And she replied: "One time when there were a group of fishermen looking for a new home they saw a big, black raven flying over them and they decided to follow the bird. The raven seemed to be calling to them:

"KLAWOCK! KLAWOCK! . . ."

Finally the bird landed on this lovely island which is part of Prince of Wales Island and at low tide is called Klawock Island.

The Legend of Creation was told to us by Adam Thomas, one of the last great totem-carvers of Klawock. By carving the poles he not only left memorials of the great Tlingit legends but also supplied his small family with food from his wood carving. Here is the legend as he told it to us.

The smartest one in the whole world was Raven. But rightly so, for did he not create all things? There was the time he made land for instance. Hear how he managed it by his cunning.

It all began when he was flying over the big waters and saw a beautiful mermaid swimming so gracefully upon the emerald deep. Raven, clever bird, fell in love with the mermaid at once and decided to pledge his faithfulness to her.

He swooped down to speaking distance and put the question. The mermaid was friendly to his attentions but before her consent was given she made one condition for Raven to meet.

"If you will make me some land so I can sit on the beach and dry my hair, I will marry you," she said.

Raven agreed to her request, and left the scene to make some land. As capable as he was, he knew he would have to have some help for such an ambitious undertaking. After pondering the matter he decided to enlist the services of a seal. He found a seal swimming in the warm waters.

"Mr. Seal," said Raven, "I need some sand from the bottom of the sea. Will you get me some?" Raven was too subtle to tell Seal what he meant to do with the sand.

"I will have to ask Frog for the sand," said Seal.

"If you will approach Mr. Frog about the sand I will do a favor for both of you," said Raven.

"Oh," said Seal, "I'd like to have a nice fur coat instead of these slimy scales. Then I could swim in the coldest water and keep warm."

"You shall have a fur coat when you get me the sand," said Raven.

Seal was off at once to the bottom of the sea. Here he found Mr. Frog, who had been listening to the conversation above and had been calculating just what favor he could ask Mr. Raven in return for the sand.

When Seal approached him Frog said: "I know what you want. Tell that sly old raven that if he expects me to let him have my sand he will have to make me Keeper of the Earth's

Treasures, once and for all."

Seal was amazed at such a request, but he delivered Frog's message to Raven who was anxiously waiting for it.

"Well, what did Frog say?" questioned Raven.

"He wants you to make him Keeper of the Earth's Treasures," said the seal.

"That's asking a lot," retorted Raven, "but tell Mr. Frog that for a generous portion of the sand, he can have stewardship of all the earth's treasures."

The seal was off again to the bottom of the sea, regretting that he hadn't asked for more than just a fur coat.

Frog filled an old frogskin with sand and gave it to the seal.

As soon as Raven had the sand he flew high into the air where the wind was blowing the strongest. Into the wind he cast the grains of fine sand which, when scattered to the four corners of the world, what do you think happened? Every place a grain of sand fell into the sea an *island* was formed, some large and some small according to the sizes of the grains of sand. (The Alaskan Indians of course did not know about the great continents beyond the seas, but were only familiar with the countless islands in the Northern Pacific Ocean.)

Did Seal get his fur coat and Mr. Frog his trust and Raven the hand of the beautiful mermaid in marriage? Oh, yes, indeed. When the mermaid had dried her hair, for the first time in her life, on the sand beach of one of the islands, the mermaid and Raven were married.

Seal in his new fur coat was a witness and Frog ever since that day has been the custodian of the earth's treasures.

From the union of Raven and Mermaid came the powerful Raven Tribe of Alaska.

The Fire Legend

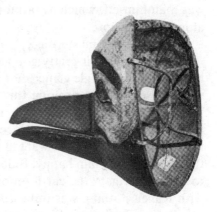

One bright and beautiful Sunday early in May Holly Tom and his wife, Ramona, took Mrs. Kaiper and me on a picnic to an old Tlingit settlement on an island about six miles west and north of Klawock. Here Holly Tom had his garden, a cleared and fertile plot of ground handed down to him through his wife's people for generations.

We built a fire on the beach near Mr. Tom's garden.

"This is not a flower garden," Holly Tom said, "but the potato-patch of my ancestors. White explorers brought potatoes to Alaska several hundred years ago."

Seated about the fire, which was a source of cheer in the damp, we ate our lunch and talked of the olden days.

"Where did the Tlingit get fire?" I asked Tom.

"There is a legend about that," was his reply, "and Ramona here can tell it in English."

After our hunger was satisfied Ramona told the story, which was made more intriguing by her soft, musical voice and by our wilderness setting.

Raven had finished making the earth, the waters, the trees, the fishes, the birds, the animals. His last stroke of genius was man himself, which he fashioned out of the clay and sand along the seashore.

"Man is my masterpiece," croaked Raven.

Yes, Raven felt pretty good about it all, so, to take in his handiwork at a single glance, he set out on a flight around the world to enjoy and prolong this feeling of a job done well. Then, too, he wanted to see if he had forgotten anything, especially anything for man's convenience. Man was his favorite, you see, and he wanted his favorite to lack nothing that would make him happy. Indeed, it was a stupendous task to circumnavigate the earth on one continuous journey, but with Raven nothing was impossible.

It was during this flight that the clever bird realized that he had forgotten to provide man with fire. Man could not cook and man could not keep himself warm. That was an oversight to be sure, and Raven, for he was the most considerate of creators, decided to remedy this oversight at once. At the end of his journey the wise bird called all the other birds to him and asked if any of them knew where he could obtain fire. The sea gull said that he had once seen fire. It was coming out of a cone-shaped mountain where is now the Valley of the Ten Thousand Smokes.

The next thing, thought Raven, was to procure a volunteer to transport the fire from that remote place. It was no easy task even for the creator to find such a messenger. Finally, the little wood owl said that he would go. Now the little wood owl had a bill much longer than any of the other birds of the forest. That is why he had felt it his duty, he said, because he could most easily carry a firebrand. It is a hard thing to believe, but actually Raven himself was jealous of the little owl's long bill. Although Raven was a generous bird he was as wise as a serpent. He began to see this fire carrying as a possible means of reducing the size of the owl's bill without himself being suspected. Yes, he had thought out a good plan and no one would ever be the wiser. The fire would do the trick.

He would accomplish two things at the same time—get the fire and burn the owl's bill short.

The ingenious bird looked around the forest and found a tree that the wind had blown down many years before and which had by this time become rotten with the exception of certain pitch-bearing branches. The boughs carrying the pitch did not rot and out of one of these Raven constructed a firebrand. The pitch would catch fire as soon as a flame was applied and it was just the medium that he needed for transferring the fire. Carefully he measured the stick and inscribed equi-distant marks about its circumference. He figured just how long the stick would burn. Upon the rate with which the stick burned hinged Raven's plan to rob the unsuspecting owl of his long bill. Raven had made the stick two marks short of what would have been necessary to transport the fire without burning the owl's bill. The owl would thus be maimed before he could reach the spot designated for the fire. This spot was to be the same pitch-bearing tree from which the brand had been detached.

Before the proposed flight was made the owl practised flying back and forth with a fagot in his bill. After many practise flights the owl gained the endurance necessary for such a long trip, and the ability to fly with a stick in his bill.

The day set for the great venture arrived at last. The owl without any special festivities and fanfare set out upon his journey, serious and determined in spirit to render this invaluable service to his brother, man. He was sure that he would succeed and if he did, he would be amply rewarded.

After several uneventful days of flying the owl reached the fire mountain which was in reality a volcano. The owl saw it afar and so terrible an aspect did it present that he had many a qualm of spirit before he finally mustered up sufficient courage to go close enough to the flame to get the pitch brand lighted. The top of the cone-shaped mountain belched forth flames and smoke. So great was the heat that before the owl could get away it had singed off some of his wing feathers, which made flight all the more difficult.

He lighted the fagot, though, and proceeded homeward. He was doing well and had nearly reached the place where he was to deposit his precious burden. Ah, poor bird! Only a few hours away from the pitch log the firebrand burned down to his very bill. Naturally the owl was of a mind to let the fire drop into the sea, but just then he heard the voice of Raven encouraging him not to let the fire, wonderful commodity, drop into the waters that would extinguish it.

"Don't give up," said Raven, "even if it burns your bill. Don't give up until you get to the pitch tree and the fire is lighted there."

Painful though it was, the owl bravely clung to the remaining bit of pitch brand which slowly but surely was burning off his bill. He had always been proud of his bill. At last he reached the place in the forest where the old pitch tree lay. So excited was Raven for fear the fire would go out, that he grabbed the owl by the wings and jammed him head first against the pitch boughs which had been laid to best receive the fire. This act completed the disfiguring of the owl. The little remaining stub of the bill was bent downward by the impact against the pitch wood of the tree.

Naturally the owl became a great hero in the eyes of the other animals, but the price he and his descendants had to pay for the honor was terrifically high. He now had a beak instead of a bill. He could no longer take long flights because of his lessened wing spread. He had to sleep in the daytime to keep the light out of his eyes. The phosphorus smoke of the fire mountain had ruined his melodious voice and had changed it to a shrill whistle.

The Tlingit parents used to tell the story to their children to point out what wonderful and seemingly impossible things can be accomplished by courage and determination.

How the Killer Whale Came To Be

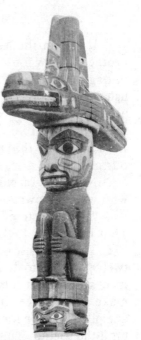

There are several versions of the Whale Killer story. When a legend is handed down by word of mouth it is apt to have varied interpretations depending upon the particular twist that the storyteller gives it. This version was told to me in Tlingit by Mrs. Kookash Brandon, a well-preserved woman in her eighties and referred to as the mother of the Brandon tribe, because her descendents constitute about half the villagers of Klawock.

The various versions of the legend all agree that the name of the man who created the whale killer was Noht-sy-cla-nay; that he tried four times before achieving success; and the particular wood that the whale killer was made out of was yellow cedar.

The purpose of the legend was to explain the presence of the whale killer among the other animals of the sea and why the whale killer has never been known to attack a man. It is an interesting illustration of the primitive's attempt to classify and explain the world around him. The dolphin, the porpoise, the whale killer or killer whale and the black fish are a species of Cetacea or whale and are numerous in southeastern Alaska waters. At least one of the species can be seen on almost every voyage of a few hours duration.

It was in the leafy June. Noht-sy-cla-nay and his three brothers-in-law found themselves in the midst of a great school of dog salmon. The fish were running earlier this season than usual and were jumping out of the water in great numbers about their dugout canoe.

"The Great Spirit has smiled upon us, my good brothers. Let's paddle to the shore and build a brush fire to show Him our gratitude."

Now two of Noht-sy-cla-nay's brothers-in-law, the two who were his own age, didn't like to go to so much trouble.

"It's a waste of time. We worship and feast all winter. That is enough. Let's busy ourselves and catch the fish."

The youngest of the three brothers-in-law, a boy about twelve, wanted to do as Noht-sy-cla-nay said but the two older men wouldn't let him. Noht-sy-cla-nay went ashore alone to make his sacrifice. He cut some branches off a yellow cedar and piled them up for his fire. Then with his fire stick he rubbed until the friction ignited some moss which in turn soon set the cedar branches to blazing. As the branches burned he noted how they crackled and popped. While this crackling was going on, to his amazement small sticks that were lying around on the beach near the water's edge suddenly became alive and jumped into the sea, all turning to eels. Frightened, Noht-sy-cla-nay called to his companions and when he told them what had happened they too expressed fear.

As the three men and boy paddled away from the shore towards their summer camp they began to discuss what had happened. The two oldest brothers-in-law, who were seated in the stern of the canoe, had always been jealous of Noht-sy-cla-nay because he was so religious. The thing that had just happened gave them more cause to dislike him.

"Witch," they whispered, "Witch!"

That night after they arrived home the two jealous ones put their heads together and decided that on the morrow they would kill Noht-sy-cla-nay and put him out of the way for good.

The next morning, as the broad sun climbed above the

rim of the range of mountains that rose to a great height to the east of them, Noht-sy-cla-nay with his three companions started north in their canoe towards the salmon horde. When they were a safe distance from camp, so as not to be seen, the brother-in-law that was sitting immediately behind Noht-sy-cla-nay raised the handle of his paddle and brought it down on Noht-sy-cla-nay's head. The blow stunned Noht-sy-cla-nay who fell back in the canoe as if he were dead.

"We'll take him way out in the ocean and throw him overboard," said the man that did this dastardly thing.

"Oh, no," cried the young lad. "You mustn't do that. The Great Spirit will punish you."

The two older men laughed and assured the boy that no one would be the wiser. As they were heading out to the open sea beyond the fringe of islets that protected the water close to shore the young man wept at his own helplessness to aid his relative whom he had come to admire even more than his own blood brothers.

"We've gone far enough," one of the men said. "Let's bind his hands and feet so if he comes alive again he can't swim."

This they did with some thongs made from deerskin. One of the brothers-in-law took Noht-sy-cla-nay by the arms and the other took him by the feet and they tossed him into the sea. The boy was so conscience stricken that he jumped overboard to be with the man his brothers sought to drown.

"If we let the boy drown it will arouse too much suspicion."

Hence they rescued him. The men set off toward the mainland with the boy again in the canoe. The boy fought and grabbed at the paddle to hamper their progress. Finally his two older brothers promised that if he would not complain they would get Noht-sy-cla-nay and put him on a reef instead of leaving him in the sea to drown. The boy consented to this so the three of them returned to the spot where Noht-sy-cla-nay floated upon the water and dragged him to a nearby reef which when the tide was high would be covered by four or five feet of water. There they left him to his fate.

Fortunately, Noht-sy-cla-nay regained consciousness before the tide came in. There he was upon a strange reef surrounded by sea lions. The Indian was frightened at first. However, when one of the sea lions spoke to him he forgot his fear.

"You've been left here to die by your wicked brothers," said the sea lion. "The boy tried to save you but he was not strong enough."

"What will I do?" asked Noht-sy-cla-nay. "I can't swim and when the tide gets high I will be washed off the reef and drowned!"

"If you come and live with us we'll save you," the sea lion replied.

"Where do you live?"

"We live on the bottom of the sea. We'll build you a nice house all to yourself down there."

"How will I breathe?" asked Noht-sy-cla-nay.

"We'll carry air down to you, plenty of it, so that you can breathe under the water as easily as you can in the forest."

There really wasn't anything else for Noht-sy-cla-nay to do but consent to this offer which he did. At once the sea lions cut with their sharp teeth the thongs that bound Noht-sy-cla-nay and carried him down, down, down to the bottom of the sea where they built him an abalone-shell house with beautiful mother-of-pearl windows.

All summer long Noht-sy-cla-nay stayed among the sea lions, who brought him fresh air scented with the odor of the hemlock and the spruce and the cedar. They also fed him smoked salmon which they took from the smokehouse racks of his own village. The abalone-shell house with the mother-of-pearl windows kept out the seas and kept in the precious air brought by Noht-sy-cla-nay's friends. When Noht-sy-cla-nay left the house to walk among the rocks on the sea bottom in search of fish eggs, sea cucumbers and crabs he would hold his breath like the sea lions do. Sometimes he could go for five minutes before he had to return to his house for some more air. It was all very much better than drowning and by keeping

himself busy he found some enjoyable aspects to his new existence.

Nevertheless, after several months of this kind of life Noht-sy-cla-nay once more began to think of his tracts of forest.

"The leaves of the bushes and shrubs are now red and brown and yellow," thought Noht-sy-cla-nay. "And the berry patches look as though a rainbow has fallen from the sky. There is a warm glow upon the surface of the waters and the whistling wings of the mallard and the teal thrill the hunter as he stalks the deer."

The sea lions noticed that Noht-sy-cla-nay was growing homesick. They were not surprised then when Noht-sy-cla-nay begged them to release him. Moved with compassion, the chief of the sea lions finally agreed that he might go.

"We shall let you return to your home upon one condition," he said. "If you make us an animal that will help us destroy our mortal enemy—the whale. If you make us a whale killer as soon as you reach the shore of the mainland, we will release you."

Delighted, Noht-sy-cla-nay promised that he would do their bidding.

Preparations for the Indian's trip back to land were made. One morning in October the chief sea lion brought Noht-sy-cla-nay the stomach of a seal.

"You are too heavy to carry to the surface of the sea," he said, "so you blow your breath into this stomach and it will help buoy you. It will be necessary though that you hold your breath until we reach air. If you can do that I think we can get you home."

After all instructions were given Noht-sy-cla-nay filled the seal's stomach with air and took one last deep breath. The sea lions fastened their kelp lines to Noht-sy-cla-nay and started with him to the top of the water. It seemed to Noht-sy-cla-nay that their progress was mighty slow. When he felt as though he could hold his breath no longer he heard one of the sea lions say, "We're only half way now."

Noht-sy-cla-nay was beginning to get dizzy. Finally, he let the air in his lungs out to relieve the pain in his chest. When he did this the chief sea lion said:

"Why did you do that? The air in your lungs helped lift you. Now you are heavier and it will take us longer to get you to the surface."

Noht-sy-cla-nay was in agony by this time. In desperation, he put the end of the seal's stomach containing the air into his mouth and sucked it all in. When the improvised buoy collapsed, he began to sink at once, and soon he found himself right back where he had started. When Noht-sy-cla-nay had recuperated in the shell house he wept with grief but the sea lions consoled him by saying that maybe they could find another seal's stomach and then they would try it again.

The sea lion chief was as good as his word. About a week later he came with another seal's stomach and by means of the two buoys they successfully reached the surface of the ocean. Once there Noht-sy-cla-nay held the inflated seal stomachs under his arms like water-wings and the sea lions towed him to shore.

As soon as Noht-sy-cla-nay reached land he set about making the whale killer using the tools one of the sea lions stole from Noht-sy-cla-nay's own camp. He fashioned, out of a spruce log eight feet long, an animal that looked like a whale only much smaller in size. When he was finished he took some charcoal from his fire and colored its back and sides black, leaving its belly white. When this animal was all ready for the water, Noht-sy-cla-nay lit a brush fire out of the branches he had trimmed off the spruce log, but nothing happened.

Not discouraged, Noht-sy-cla-nay took a hemlock log and carefully carved another animal. He colored it black by rubbing a burnt stick across its back and underside. When it was finished, he built a brush fire out of the trimmed branches, and waited for life to appear in the log. But the carved hemlock animal just lay still on the beach.

Noht-sy-cla-nay laughed good naturedly and decided to try it again. This time he carved an animal out of red cedar. The

log was only six feet long but because it was a good solid log Noht-sy-cla-nay decided to use it. He shaped the animal's snout so as to produce a distinct beak. When this was done he sprinkled it with a handful of the ashes which he took from the fire. This gave it the appearance of being colored a two-toned gray. Where the ashes were thin the red cedar shone through making red spots here and there. With anxiety he lit a fire out of the red cedar branches. For the third time nothing happened.

"Well," said Noht-sy-cla-nay, "there is only one other kind of tree out of which I could carve an animal large enough to kill a whale and that is the yellow cedar. If that doesn't work I've done the best I can and my debt to the sea lions is paid."

He looked a long time for such a log, and after a week's search he finally found one that was near enough to the beach so that he could handle it. He floated this log along the shore to the spot where the other three animals he had carved lay. Because it was to be his last attempt he made an animal about thirty feet long. It had a high dorsal fin, a strong and powerful tail, and sharp teeth. As usual Noht-sy-cla-nay lit a huge brush fire of the yellow cedar limbs. As the flames leaped into the air the yellow cedar branches popped and crackled. Then he remembered how the branches crackled in the same manner when he made his prayer to the Great Spirit the June before.

"Why didn't I think of that? The spruce, hemlock and red cedar branches didn't crackle when they burned."

Suddenly, the huge animal leaped into the sea along with the other three smaller ones. So satisfied was Noht-sy-cla-nay with his ultimate success that he jumped up and down upon the beach and clapped his hands in joy. As he stood on the beach watching the animals he noticed that besides the difference in size of these four animals the three smaller ones could not dive very deeply below the surface of the sea.

"The three smaller animals will not be very efficient for killing whales. They'll do for food," exclaimed Noht-sy-cla-nay. "My tribesmen can catch them and eat them!"

The big animal made out of yellow cedar could hold his

breath for a long time and dive down deep beneath the sea's surface just like a whale could. Thus Noht-sy-cla-nay named him Mr. Whale Killer. The animal he carved out of spruce wood he called Mr. Porpoise. Noht-sy-cla-nay looked at the animal, the small animal made out of hemlock and colored black. It looked blacker still in the water.

"I'll call him Mr. Blackfish," he said.

While Noht-sy-cla-nay had been naming Mr. Whale Killer, Mr. Porpoise and Mr. Blackfish, the animal carved out of red cedar was swimming around and around sometimes jumping out of the water altogether just in play. The Indian noticed it and laughed.

"He's a spirited fellow! A good name for him will be Mr. Dolphin. He gallops when he swims."

The Indian's work was done. He could go now and join his fellow-tribesmen from whom he had been separated so long. He took one more look at the fine animals now alive and swimming about. Just as he was about to leave them the sound of human voices reached his ears. So he tarried a bit to see who was passing that way. Finally, from behind an islet to the south of him, there emerged a canoe bearing two men and a boy. He recognized at once that they were his three brothers-in-law. Noht-sy-cla-nay hid behind a tree and told the sea animals to hide also. When the men came within hearing distance he heard the two oldest brothers-in-law laughing and talking about how they had done away with him and that no one had suspected them of murder. Noht-sy-cla-nay's anger was instantly aroused. They themselves had reminded him of their foul deed. When the canoe had passed out of sight again around a point of the beach the Indian called the whale killer to him and said: "I am your chief, Mr. Whale Killer! Go at once after my brothers-in-law and smash their canoe. Save the young boy because he is good but drown the two men."

The whale killer was off at once for he knew his chief's voice. Coming upon the men in the canoe the whale killer smashed into it headlong shattering the canoe into splinters and depositing the men and the boy into the water.

"Climb upon my back, boy," said the whale killer.

The boy did as he was told and the whale killer carried him to a nearby reef where he left him temporarily. From that place the whale killer went after the two men who were swimming frantically towards shore. When he came upon them he swished with his mighty tail and whipped the water thereabouts into a seething foam. The brothers-in-law were soon drowned.

In the meantime some sea lions took the boy off the reef and carried him to their house made of shells on the bottom of the sea. When the whale killer returned therefore the boy was nowhere to be seen. The whale killer reported what had happened to Noht-sy-cla-nay at once. When the Indian heard the news he became worried. All that night he thought about his young friend.

About daybreak Noht-sy-cla-nay heard a voice. He arose and looked out of the window of his hastily built shack. There hovering over him in the breeze was a sea gull.

"The boy is safe," said the sea gull. "The sea lions have him and will release him to you as soon as you fulfill your promise to them."

With that message the gull was gone.

Noht-sy-cla-nay, in his desire for revenge, had temporarily forgotten why he had made the whale killer. When he was reminded of it he called the whale killer to him.

"I am Noht-sy-cla-nay, your chief! You are not to kill any more men. I made you to kill whales and so help the sea lions fight their mortal enemy."

When the killer whale received these instructions from Noht-sy-cla-nay he put out to sea in search of whales, and did not harm man after that day.

The sea lions were as good as their word. They brought the boy to Noht-sy-cla-nay that very hour. Once reunited these two friends continued throughout their earthly life as inseparable companions. Even now it is said among the Indians on the west coast that in October you can hear their voices from the spirit world as Noht-sy-cla-nay and his friend join each other in the hunt. Some, though, believe that the voices are only the whisperings of the wind in the spruce trees.

The Beaver, the Bear and the Ground-Hog

One day Mrs. Kaiper and I packed our camping equipment and set out for Three Mile Creek, a small stream that flowed into Klawock Lake about three miles above the lake's mouth. Here among a clump of alders stood the remains of the hatchery house, a frame building constructed by the government years before to experiment with spawning salmon. Since some of the building still stood intact, it afforded an excellent retreat in case of stormy weather. On this particular occasion when we arrived there we found a young native man with only one arm bending over a fire roasting a piece of venison. We recognized him at once as Paul Friday. He had lost his arm when a shotgun accidentally discharged. When the native saw us he invited us to join him in the feast. We also had some provisions and between us we had a fine dinner.

After the repast had been cleared away and we were settled comfortably by the fire, Mrs. Kaiper said: "Mr. Friday, isn't there some legend that accounts for this beautiful lake?"

"Yes, there is," replied the Indian. It is the legend of how we acquired the Bear, the Beaver and the Ground-Hog.

After I became more familiar with this legend I found that the natives told it for different purposes. Some used it for the moral it contained, namely, that might does not always make right; and the corollary, that it is not always wise to live in a place that affords ease and luxury.

Still others telling the legend used it as a fireside tale and referred to it as the story of the lake.

When Rob Minovitch told the story he would usually say: "The white missionary is the beaver who makes us natives climb to rougher but healthier ground."

There was a time when the animals still had the world to themselves, and did not have to be careful of their great and mortal enemy, man, but even then each family had its troubles. The big animals were always persecuting and tormenting the smaller ones, or killing one another in long, disgraceful feuds.

Such a feud existed between the beaver and the big Alaska brown bear. The brown bear, because of his size and superior strength, was always breaking down the work of his neighbor, the beaver. The beaver is a very careful, clean and painstaking animal, as you know. He is forward looking too, putting away bits of hemlock and alder sticks for the winter to munch upon while the wind blows down from the north, and the snow flies through the air covering up all the tender young shoots of the trees.

Did you ever watch a beaver at work? If you have not you have missed one of the most interesting sights in the north woods. It is especially fascinating to watch him fell a tree in the construction of a dam across a stream. He works fast but knowingly. He even makes allowance for the direction of the wind, and if while working on a tree the wind changes, the beaver will stop until the wind blows in his favor again. He literally gnaws the tree down with his sharp front teeth. Like an experienced woodsman, he makes a cut on the side toward which he wishes the tree to fall. Then he goes around on the other side and cuts toward the center and past it until the tree falls. He cuts smaller trees too, and drags them, sometimes for hundreds of yards, to the dam and weaves them in with mud to form a wall that will hold back the water.

The big brown bear does not have to work nearly so hard for what he wants and thus does not accomplish nearly as much as his smaller brother, the beaver. The brown bear is not careful about his eating either, but just takes a bite out of this and that, blundering and blustering along, knocking things over, not caring about the future, for he is so big and strong that he can get food to eat any time he wants it.

One day Mister Brown Bear came upon a beaver dam. Feeling mischievous, he decided to tear it down, just for the fun

of it. But the dam held back the waters of a river from a very large valley where many other animals had their homes, including the bear himself. In this valley the small ground-hog used to play and romp in the sun and eat the tender weeds and herbs that grew in the rich loamy soil. It was here that the bear had his cave because it was easy to get around on the flat land of the valley.

The beaver came out of his hole and warned the bear not to destroy the dam, but do you think the bear would listen to so small an animal as a beaver? Not he, no sir. He shut his ears and began to tear down the logs with his huge and powerful claws.

Suddenly the force of the water pushed the weakened dam before it. It carried the bear, large as he was, just as if he were an ant, down, down into the valley below. Now the beaver had warned all the others of his family when he saw that the bear would not heed him, so they luckily escaped to higher ground before the wall of water gave way. Not the poor ground-hogs, however, for when the avalanche of water came down upon them, they were all drowned except one. All the bears perished likewise, for they were trapped in their caves and could not escape. The only one to be on top of the water was the bear who had done the mischief. Too bad it was not he who had to suffer for his willfulness.

As the rushing torrent eventually subsided, the valley was filled up with water, and a huge lake was formed. There in the middle was a big brown bear, almost worn out by his frantic swimming, and one poor little half-drowned ground-hog. The ground-hog asked the bear where he was going.

Bear answered in a gruff voice: "Do you see those two mountain peaks straight ahead? That is where *I* am going."

"Surely I will drown before I can swim that distance," the little ground-hog replied, "I am much too tired to go any farther."

Bear told the ground-hog to grab hold of the fur on the back of his neck and he would take him to the peak in safety. Gladly the ground-hog agreed, for, thought he, to be slain later

by a treacherous bear was better than to be drowned right now. The powerful strokes of the bear soon brought them to one of the high peaks. Because the bear had never been in water over his knees, he was at a loss to know how to get his shaggy coat dry. The ground-hog, on the other hand, knew how to shed himself of the water very quickly and effectively, and he told the bear he would show him the trick if the bear would agree not to harm him. By this time the bear had learned to respect somewhat the work and craft of the beaver, so he promised the ground-hog that never again would he molest smaller animals. The ground-hog thereupon shook himself and the drops of water fairly flew from his fur. Then the bear tried, but because of his clumsiness, he could shake only his head. Finally, though, he managed to wriggle his body and soon he, too, was dry. This was the first time any bear had ever tried to dry his fur without taking it off and hanging it on a bough in the sun, and this, too, he had learned from a creature smaller than himself.

"Where are you going to make your home now?" the ground-hog asked the bear.

"Among the rocks on this side of the peak," the bear replied.

"Very well," said the ground-hog, "I'll make my home on the other side of the peak, so as not to be in your way."

And so the bear learned humility, and found a safer place to live. The ground-hog, too, was wise not to build his home again in the marshy lowland; comfort and ease, he decided, were not necessarily a guarantee of long life.

"I will build my house beneath a rock," he said, "where the storms cannot wash it away."

The lake, of course, formed by the rushing waters of the broken beaver dam is now known as Klawock Lake.

How Tecumseh Became
a Great Fisherman

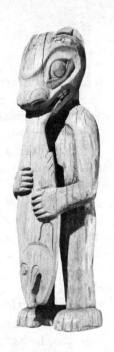

The Tecumseh legend is still generally used to rationalize the seafaring life of the Tlingits and to uphold the old traditions of the Tlingit people. The majority of the Tlingit young men and women of today depend upon the fishing industry for their livelihood. The men work on boats and the women in the canneries. A fishing season has no sooner ended, usually sometime during the first week in September, than attention is given to next year's catch. All winter long plans and preparations are made for the king salmon trawling that usually begins in April and the seining season that begins about the middle of July. It is the dream of all native fishermen that the next season's catch will net them an income to afford better equipment for the seasons to come. The life of a Tlingit literally turns upon an axis of fish. The pay-off after a fishing season is when most debts, accumulated during the previous year, are settled. Credit is usually extended to native fishermen by local stores a year in advance of a fishing season on faith that all bills will eventually be paid.

This version of the legend was told to me in English by Holly Tom. Mr. Tom was an expert trawler and carpenter. He was educated at Sheldon Jackson School at Sitka, Alaska, where he learned the art of boatbuilding. He was the father of five children. His own father was a famous guide to hunting parties from the southern States.

A great many years ago, in the village of Klawock, Alaska, the Tlingit Indians were enjoying a potlach. Now a potlach is nothing more than a native festival, given by one family for another, to celebrate a particular occasion, such as a marriage, or a death, or the going away of a son.

Sometimes the merry-making and eating and dancing lasted for a week or more. Since the natives believed it more blessed to give than to receive, the Chief who was able to give the most away was held in greatest esteem. The gifts were food, especially herring-eggs, and dried seaweed, eulachon oil, smoked salmon, and jerked venison. Happy indeed were the guests who received fine blankets made from wool of mountain goats by neighboring tribes on the mainland.

On this day Chief Eagle Horse was to give away his oldest son, now twelve years of age, as was the custom of the tribe. No doubt you know that the son of a Chief when he reached that age, could no longer live in his father's house, lest his father's affection be his own undoing. For to make him a leader of his people, a master in hunting and fishing, in character and in craft, strenuous training was imposed, away from his father's indulgence. The man chosen for this important task was the uncle who was nearest in kin.

Thus Tecumseh took leave of his childhood home to embark upon the long course of trial and suffering which would make him a wise and noble Chief one day. Willingly, he went without food for several weeks at a time to test his fitness and his courage. He did not complain at being thrown into icy seas, for he knew this helped to make him strong. He learned to run barefoot after deer, over rocks and through the woods in the heat of summer and the cold of winter. He could paddle a canoe without rest for many days. As time went by, he learned how to hunt the seal and the otter, how to catch salmon, halibut and red-snapper.

He learned many other things too during the next five years, yet his uncle was not satisfied. For Tecumseh, at seventeen, was neither so strong nor so wise as his father had been, nor would he make so great a chief. And his uncle, who had taught him, was sorely grieved.

Tecumseh, unhappy at his uncle's displeasure, determined to do better than he had in the past, although always he had done the best that he could. When he failed to catch his share of the fish, he remained in his boat all night to finish his work and to punish himself. Try as he would, he could not please his uncle, or himself, for both knew he was not the man his father, Chief Eagle Horse, had been.

He went fishing one day with his uncle, who now spoke to him scarcely at all. Near Cape Lynch a storm broke upon them and swamped their eighteen foot dugout canoe. Because of his superior strength his uncle was able to swim to shore, but the young Tecumseh was quickly drowned in the surf.

That very night Tecumseh's mother had a dream in which she saw her son swimming along the sea floor with a large school of salmon. Since the Tlingit Indians believed that all dreams were significant, the mother never gave up hope that she would see her son again some day. When she went out fishing with her husband, the Chief, she always called to the salmon in her son's name, begging them to speak to her. But nothing happened.

The year after Tecumseh was drowned, no salmon at all came to spawn in the creeks about the village. Salmon, you know, are hatched out in fresh water streams where their salmon parents lay their eggs in the fall of the year. After the eggs are hatched out the baby salmon swim down these fresh water streams to the salt water of the sea. Here they grow to maturity and in about three years they come back to the same stream in which they were born to hatch out their young. They come in great numbers to the place of their birth, where the natives catch them either in nets made of spruce tree roots or with spears whose shafts are cedar, whose points are bone.

But this fall there was famine in all the land. No deer or ducks made their appearance on the grass flats around the stream inlets, and all the tribes in Southeastern Alaska were suffering because of lack of their most important food—fish. Even the oldest and wisest fishermen shook their heads, and could not tell why the salmon did not come to spawn in the nearby creeks. Was the tribe of Chief Eagle Horse doomed to

starve and perish in the cold and wet of the long winter to follow?

One evening in the light of a sad moon waning over the village, Tecumseh's mother took her little dugout canoe and began to paddle out into the bay. She had not gone far when she spied a large fish jumping in and out of the water ahead of her. It jumped time and time again as if trying to attract her attention. Finally, with a mighty flip of its tail, it flopped right into the bottom of the boat. A beautiful fish it was, the woman saw—a full grown sockeye salmon, fat and shimmering. Quickly, she placed it in her basket, and made for shore.

Now it was taboo to dress a fish for cooking if it appeared to be inhabited by a spirit. Instead, it was wrapped in cedar boughs and laid upon the roof of the house, to warn the spirit within that the fish would soon be killed, and to coax it forth.

Three days after Tecumseh's mother had caught the big salmon, her husband, Chief of the tribe, took it from the roof to dress it for roasting. As he was about to cut off the head, he heard a voice say, "Do not harm me, father." the Chief hurriedly withdrew the knife, and as if by magic, before his very eyes, the salmon was transformed into his own son.

You can imagine the happy reunion which followed. All the people of the tribe, called together by the Chief, rejoiced and laughed and danced in happiness to know that Tecumseh had been restored to them. In their great joy, they forgot for a time their hunger. Then Tecumseh said to them, "My people, I have brought for you a gift," and all the people wondered, as they could see nothing. But Tecumseh smiled, for he knew what they were thinking, and he knew also the great value of the gift which none could see. Did he not know where the salmon were hiding from Indian nets and spears? Could he not lead his starving people to the spot?

And in this fashion Tecumseh, the frail, slow-learning Tlingit lad who refused to give in to despair, became the best fisherman of his tribe and the savior of his people. Small wonder the Tlingit Indian is the best of all the Indian fisherman, for is he not descended from Tecumseh, who at one time was a fish?

The Devil Fish

One raw January day, Jerry and Edwin, eleven and thirteen year old sons of Henry Murphy, a white homesteader who lived about two miles outside of Klawock, had a most unusual experience. The two boys were walking along the shore of the bay near their home when they saw what they thought was a dead devil fish or octopus. The natives always used the word "devil fish."

"I guess the recent storm washed him in," said Edwin.

Jerry, the younger of the two boys, waded into the water and poked the thing with his finger. Immediately the devil fish became alive and grabbed the lad with its tentacles, wrapping one around Jerry's wrist and one around his ankle. Then, with its characteristic rolling motion, the octopus began pulling the boy out to deep water. Edwin saw what was happening so he gave chase and plunged his hunting knife into the slimy torso of the creature, between his two large eyes. The blade struck a vital spot and the two boys hauled the stricken devil fish to shore.

Its longest tentacle measured six feet. The fish weighed about seventy-five pounds. Mrs. Murphy made soup out of one of the tentacles. Mrs. Kaiper and I were invited to the occasion. The meat was white and tasted something like the clam and abalone. The natives were particularly fond of devil fish tentacles, which they fried or boiled in a chowder.

The incident made quite an impression upon the Tlingits of the nearby village for it was the largest octopus seen about Klawock in years. It revived an interest in the old native legend about the devil fish, and blind Grotan was kept busy for a week telling it to interested groups who gathered about the bottle-neck stove in Rob's store. Grotan had just about finished relating the legend one day when I walked in. When he knew it was me he invited me to join the group and he began all over again just for my benefit.

Once upon a time, when the Dog Salmon Tribe of the Tlingit nation first began to make their winter home at Devil Fish Bay, a frightful tragedy befell them.

One June day two men and a boy were on the bay, now known as Shipley Bay, spearing seals. They were well-equipped for their task and besides their fine spears, with tips made of whale bone, they each carried rare knives made of iron.

The men in the canoe were busy plunging their spears into the seals as they poked their heads up out of the water to get a breath of air. The seal breathes through the nose and mouth. It can hold its breath for a long time, but it has to come to the surface occasionally to get fresh air. One of the men speared a seal swimming just under the surface of the water. But the seal, instead of struggling to free himself as seals ordinarily do, made strangely human sounds as if trying to tell the hunters something. The noises came in snatches like a conversation in a strange tongue. The older man, being wiser, interpreted it as a warning of bad trouble back at their village, and urged the others to return home with him as quickly as possible. With long, rapid strokes of their paddles they made their dugout canoe fairly leap through the water in the direction of Dog Salmon Creek.

Weaving in and out among the wooded islands, through tide rips and kelp they hurried, and in less than a day they came within sight of their village, built on both sides of Dog Salmon Creek. That something terrible had happened was apparent to them all, for in the water two miles from the village floated totem poles and moccasins, and the debris of demolished cabins. How those men in the boat must have felt, watching their own smoke-houses and their own fish racks being carried by the tide and currents like so much driftwood!

They approached the mouth of the creek with sorrowful hearts. Their village was desolate, the houses all gone. Not a person could they find, not the tiniest baby. Nothing was standing save a few of the giant spruce trees with roots so deep the strongest wind could not dislodge them.

What events could have led up to this terrible

devastation? The day had started peacefully enough, and a small boy from the village sat watching his parents clean fish on the shore alongside that deep part of the bay where a giant devil fish made his home. His uncles had gone elsewhere in their big canoe and the boy, impressed because his parents had caught so many good fish, said in a spirit of pride and bravado:

"I'll bet that old devil fish would like to have these salmon but he's afraid to come up and get them."

Just those few words out of the mouth of a small boy started all the trouble. The great devil fish heard the boast and challenge, dislodged himself from the rocks at the bottom of the deep bight of water, and slowly rose to the surface before the frightened and horrified natives. He stretched out two of his great tentacles, each hundreds of feet long, and pulled the whole village as well as the fish into the bay. Not an Indian escaped and not a building was spared. In a few frightful minutes all was over, and nothing was standing save a few of the giant spruce trees with roots so deep the strongest wind could not dislodge them.

Grief sharpened the minds of the three men in the canoe, and they knew instinctively what had happened. They beached their boat under Devil Fish Cliff. Here they cut down young trees and sharpened them to points with their knives. Then they built a fire and heated seal oil, into which they dipped the points of the sharpened poles, to make them very hard. Their next move was to take the young boy up on the cliff overlooking the bay. Here they made a comfortable nest for him. They filled a seal's stomach with water for him to drink and roasted chunks of the seal meat for him to eat, and placed them in the nest with the boy.

"You are to watch and see what happens," they told him. "You are to tell the first person who comes along just what you see. We are going to avenge our people and kill the devil fish. Our law is an eye for an eye and a tooth for a tooth."

To make the devil fish come to the surface the two brothers first threw big rocks into the water from the cliff. The rocks plunged down with great force and the splash as they hit

74

the water rose fifty feet into the air, but nothing happened. The devil fish, sixty fathoms down at the bottom of the bay among the rocks, paid no attention at all.

The men changed their tactics. By cutting up a porpoise in the water they made the surface of the bay red with blood. Then they began to taunt the devil fish, saying:

"Come up and fight with brave men. You are afraid to fight men with knives but attack only the helpless and defenseless women and children."

Soon bubbles began to rise to the surface of the water from out of the depths of the bay. More and more bubbles arose, a sure sign that the octopus was coming to the top. The men hid under a blanket near the shore. Every once in a while one of them would take a look and the man under the blanket would ask: "How far down is it?" And the answer would come: "He is still down deep."

(Even today this expression is used by members of the Dog Salmon Tribe. When one of them is on his death bed, perhaps, a fellow tribesman will say: "How far down is it?" meaning how far away is the monster death. If the one who is to die feels that it will be some time before death arrives, he will answer: "He is still down deep.")

When the devil fish finally reached the top of the water in the bay the brother who was looking said:

"Now it is up to us!"

They tossed the blanket aside and took their sharpened poles and began poking the devil fish in its eyes. This did not seem to harm him, though, and the younger brother jumped into the slimy yellow-green mass with his knife. Before he could cut with his knife, however, the inky black fluid that the devil fish gave off poisoned the man so that he died instantly.

Next the older brother leaped into the gelatinous slimy mass which was the devil fish's body. The older brother was stronger and he succeeded in cutting long slashes across the devil fish between its two demon-like eyes. There lie the nerves which control the eight tentacles, and should they be severed, the devil fish is helpless and soon dies. The older brother finally

succumbed to the poisonous and inky fluid and became a corpse like his young brother. He did not live to know that he had mortally wounded the devil fish.

The lad in the nest above the bay saw the revenge fulfilled. That two men with knives were able to slay the demon which had destroyed the whole village seemed incredible but he had seen it all. His two brothers had successfully avenged the death of their people but had lost their lives to the cause.

As his brothers had predicted, the very next day two men came from what is now Camp Taylor to Devil Fish Bay. The boy saw them coming and left his hiding place to meet them. He related what had happened so vividly that the two strangers did not doubt the veracity of his statements. They could see for themselves that the village was gone and there was the giant monster on the beach dead. What more proof did they need?

The three began dissecting the fish to get the two dead men out of its stomach, the two brothers who had killed it. The two newcomers took the dead men and the boy who had watched the battle back to Camp Taylor with them. Here they reported the destruction of the devil fish and the heroism of the brothers.

Although the two brothers killed the octopus who destroyed a whole village, the death of one octopus evened the score for the death of only one Indian. Thus the "devil fish" still is indebted to the Dog Fish Tribe of Indians, according to the code of an eye for an eye and a tooth for a tooth, and always will be indebted to them until an octopus is killed for each Indian slain that day in the waters of Devil Fish Bay.

Legend of the Halibut Hook

It was early in April and the snow of the mountain slopes was gradually receding. One morning as I was standing on the veranda observing these signs of coming spring, I noticed a crowd gather on the beach. I soon joined them to get in on the excitement. Andrew Tobert had caught a large halibut, which when weighed tipped the beam at seventy-five pounds. Some of these fish get as large as several hundred pounds. When they grow to this size, however, the meat is coarse and has not as high a market value.

I helped Mr. Tobert carry his catch up the hill to his home and en route asked him how he caught it.

"I hand-trawled for it," said Mr. Tobert.

By hand-trawling he meant a wire line run on a hand-reel fastened to the side of his canoe. Halibut trawlers usually used a hook with a highly polished spoon spinner for a lure.

"Did the Indians always catch their halibut that way?" I asked.

"No, we had halibut hooks made out of a forked stick with a bone barb." He showed me some his father had used before him.

That night the Toberts invited us down for halibut steak and as we ate of this delicious white meat Andrew recounted the legend of How the Halibut Hook Came to the Indians of Southeastern Alaska. This legend was told chiefly among the Tlingits for entertainment.

Many years ago, when the animals were much more numerous than they are now, the Alaska brown bear used to be the best fisherman below the Arctic Circle. His great bulk and unlimited endurance, his great strength and long claws fitted him naturally for this pursuit. He would spy out a fish and then dive for it. So quick and agile was the bear that the fish could not escape despite its best efforts.

While the bear was fishing one day in the kelp-strewn waters off Admiralty Island, a sea animal resembling a fish, but able to talk the language of the bear, swam slowly around, watching. When he was certain that the bear was no longer hungry, he approached him to have a little talk. The sea animal spoke first, diplomatically praising the bear for his ability to catch fish. This pleased the bear immensely. Then the sea animal told the bear that he knew of an easy way to catch halibut.

"Go to the woods," he advised, "and find a forked limb. On the lower prong fasten a sharp piece of whale bone so that the point faces toward the fork. To the prong to which you have fastened the bone barb, attach a kelp line. To the loose end of the line tie a stone. Now, to the upper prong fasten another kelp line and hold its loose end in your paw. After you have covered the barb with a small herring so that the halibut cannot see it, throw the hook with its stone sinker into the deep water off some rocky ledge. Keep the loose end of the kelp that has been fastened to the other prong in your paw, so that the hook will be suspended vertically in the water."

The bear was instructed to carve the upper prong to resemble himself.

"Jiggle the hook up and down occasionally," said the sea animal. "By talking with your image you will know just how close the halibut is."

The bear knew that the halibut did not swim belly-down as other fish, but, like the flounder, on its side. The sea animal told the bear that the halibut would strike at the herring, and when he did so, he would wedge his nose and mouth in between the two prongs. Because the barb pointed toward the fork, the

halibut as he tried to back away, would embed the barb in his mouth, securely hooking himself. The bear was delighted with the ingenious idea, and he saw at once how practical such a hook would be.

To be sure, this knowledge gave the bear a distinct advantage and made him the envy of all the other animals. He always had been a good fisherman but now he could catch fish without even getting wet. (In the days to come his halibut hook was never improved upon, even by the white man.) The bear guarded his secret very carefully. When he was through with the hook, he put it into a bag he had made out of buckskin. Never did he let any one examine it.

Mr. Raven was among those who coveted the bear's secret. Again and again Raven flew over the bear while he was fishing but the bear never pulled the hook to the surface when Raven was around. Certainly, Raven was far from being a dull bird, and he began to scheme how he could learn the bear's secret. Finally, he fell upon a plan. One day he went up to the bear when the bear had just finished fishing, and asked him for the stomach of one of the halibuts that he had caught. The bear did not see any harm in this, so he gave Raven the stomach of the biggest halibut. The sly old bird took the fish stomach behind a hill. There he built a fire and heated some round stones until they were nearly red hot. Putting them into the fish stomach, he hastened back to the bear with them.

"Mr. Bear," he said, "because you have been so good as to give me the fish stomach, I have cooked you a dainty morsel to eat with the fish."

The bear growled his consent for he was busy chewing on a halibut head.

"Open your mouth," said Raven. "You don't have to chew the food the raven cooks, just swallow it whole."

"Silly bird," thought the bear, "but I'll do what he says and get it over with."

The bear opened his mouth wide and Raven dropped the stomach containing the hot rocks down the bear's throat. The bear could not feel the hot rocks through the fish stomach at

first. He gulped them down with one swallow and not until it was too late did he realize that Raven had tricked him. Soon the hot rocks began to cook his stomach and the bear fell upon the ground and writhed in pain. In a very little while the bear died, leaving the wicked raven the master of the situation.

Raven lost no time in undoing the buckskin sack where the halibut hook was concealed.

"So this is the hook with which the bear has been catching so many fish," said Raven to himself. "My, what a crude and simple thing it is after all! It's a wonder I hadn't thought of that myself."

Raven was very conceited, you see, and often took the credit for what other animals had taught him. After making himself familiar with every detail of his prize he put it back into the bag and proceeded to skin the bear.

"This skin might come in handy sometime," he said aloud. "I'll just take it with me."

When he reached home he hung the bearskin up to dry and went off again with the bag containing the hook. A short way from home Raven came upon a group of children making merry at a herring roast.

"Look at those good-for-nothing young scamps eating that nice herring," said Raven. Then an idea came to him. "I know what I'll do," he mused. . . . "I'll wrap myself in the bearskin and frighten the children away."

This he did, and the children scattered in fright, forgetting the herring, which Raven gobbled up as fast as he could. When the children got home they told their elders what had happened. The chief of the tribe advised them to arm themselves with sticks and clubs and beat off the bear if the same thing happened again on the morrow.

The next day the boys and girls went out to have another herring roast. But first they armed themselves with sticks and clubs. Raven came disguised as he was the day before. As he neared the children he imitated the bear's growl. Then to his surprise all the children jumped upon him with their sticks and beat him unmercifully. When Raven could stand it no longer,

he threw off the bearskin and revealed his identity. He pretended it had all been a joke. Then they caught sight of his bag, and they threatened to beat Raven some more if he did not let them see what was in it. Thus he was forced to divulge the secret he had tried so hard to keep. Raven, however, did not wish to give the children the satisfaction of knowing that he had been forced to do something against his will. He pretended he had brought the bag purposely as a gift to them.

Moral: Deceit is like a two-edged knife. It brings grief to the oppressor as well as to the oppressed.

The Deer, Wolf, Raven and Fox

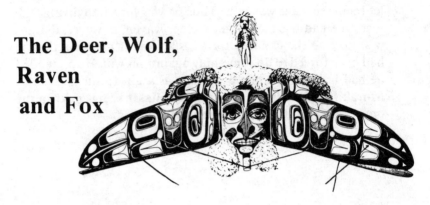

This legend has a definite moral. It was told to me by Chief Eagle Horse, a Sitka Indian who was related to the Brandons of Klawock by marriage. Chief Eagle Horse was his stage name. He chose the wolf story to tell because, as he said, "it is a typical Tlingit legend." I have never met a more cultured gentleman anywhere than Chief Eagle Horse. He was an Indian baritone and had traveled around the world with a stage troupe. At the time I knew him, nine months prior to his death, he was married to a charming French woman whom he had met in Paris, France.

Mr. Eagle Horse said that fishing was in his blood and he had come back to the mountains and streams of his nativity to die as do the spawning salmon. I had the honor of preaching his funeral service, and pronouncing the last benediction over his grave.

We had had many talks together about strange lands and out-of-the-way places. He often told me that the two most beautiful spots in the world were Sitka, Alaska and Pago Pago, on the island of Tutuila, American Samoa of the Southwest Pacific. Mr. Eagle Horse said that he liked these two spots the best because he could feel the rain in his face almost every day of the year.

This Indian was descended from a long line of Tlingit chiefs. He was tall, straight, and very handsome even in his old age. A few days before he died he sang at the church. His favorite religious song was "His Love is Like a Flower," by R. Bronner and H. W. Petrie.

During the World War of 1917 Chief Eagle Horse toured the country assisting the U.S. Army in the recruiting of men for the American Expeditionary Force.

There was a time, many, many years ago, when the Wolf was actually afraid of the Deer. One reason for this was that the Deer had such a large, fat body, and another, that he had such long, sharp horns. When the Wolf met the Deer in the woods, he would leave the trail to allow the Deer to pass, whereas the Deer would not be the least concerned by the howls of a pack of wolves on the coldest winter day.

Raven, too, illustrious bird, Creator of things upon the earth, was not above feeling envious of the Deer. At certain times of the year the Deer had two long comb-like appendages which hung down from each nostril like the comb of a turkey gobbler, but instead of being red, they were straw-colored, and looked like bunches of fat. At first the Raven admired them, but then his admiration turned to envy, and he began to plot how he could steal them from the Deer.

Part of his plan was to flatter the Deer whenever possible, and to do everything he could to convince him that Raven was a good friend. In this way he learned some things he wished to know. The unsuspecting Deer told his friend, Raven, that in each nostril he had a small bean-like gland which produced fat. In the summer when food was plentiful, the surplus fat was stored in the two combs which dangled from his nose. But in the winter, when food was scarce, the Deer used the fat from his storehouse, and the more he used the smaller his combs would grow. Sometimes, in the dead of winter, he used the whole supply and then you could hardly see his combs at all.

"Ah," thought the Raven, "that explains how my friend keeps fat and sleek the year around."

Now the Raven had built his nest high among the crags on a rocky hill, which was the reason he had so few visitors. Three sides were rough and steep, and one side a gently rolling slope, but alas! at the bottom was a deep chasm too wide to jump across. And that chasm was to be Deer's undoing.

"I shall build a bridge," decided Raven, "which looks strong, but isn't and invite Deer to visit me."

First of all, he gathered full-grown celery stalks, tough and woody on the outside, but all pith within, and not a safe

material at all to use in making a bridge. Raven worked steadily, and a stout structure it did look when he had finished it. But he was not satisfied.

"Suppose," he said to himself, "the Deer asks me to test it for him, what then?"

So the canny bird wove some tougher stalks among the others on each end, remembering very carefully where they were.

"Now," the Raven said, much pleased with the idea, "I have only to hop in the right places and the Deer will never guess the bridge is unsafe."

Very shortly thereafter he invited Deer to visit him.

"I should like to very much, my friend," the Deer replied, "but I cannot jump across the chasm, and it takes too long to go around the hill."

"But I have built a bridge to accommodate my friends," Raven assured him. "You will never have to go around the hill again. Come and see."

They started off together. Deer, indeed, was much impressed with the job Raven had done. The bridge was beautiful and certainly looked strong enough. While his friend was admiring his handiwork, Raven jumped vigorously up and down on the hidden stronger stalks, to prove the bridge was safe.

"When you cross," he advised Deer, "do not look down."

Deer had not taken more than a few steps when the bridge gave way, and down he tumbled, bumping against the rocky slope. Raven, who had magic powers, did not wish his friend to be killed, so he uttered the magic words which quickly halted Deer's descent. He looked over the side of the chasm, and there was Deer, halfway down, standing upon a narrow ledge.

Pretending to be concerned and horrified at the accident, Raven flew down quickly and began to apologize.

"Someone who saw me making the bridge must have weakened it as a joke," he explained.

Deer was glad to be alive and safe, and he forgave Raven willingly enough. His appendages, however, had been broken

off as Raven planned. As a matter of fact, Raven already had them hidden beneath his wing, and now was trying to decide how to get his friend back up the mountain.

"I shall have to sharpen his hooves so he can climb out," he thought. For up to that time Deer had hooves like square blocks of wood, and could walk only on flat land and very gentle slopes. But when Raven had finished sharpening them, he climbed the rocks easily.

Deer was so pleased with his new sharp hooves which he could use for fighting, too, that he scarcely felt the loss of his two appendages, although he knew he would never again remain fat the year around. He ate as much skunk cabbage as he could, and certain kinds of leaves, which grew in abundance throughout the summer. But by the time the first snow fell, Deer was hungry and very scrawny indeed.

Then one day he met a Wolf at the top of a hill, almost bumped right into him. The Wolf looked at Deer in surprise; he was staring so hard he forgot to step aside to let Deer pass.

"Good gracious," he thought to himself, "what has made Deer so poor and thin?"

Deer, on the other hand, was offended because Wolf stood so squarely in the middle of the road, and he was frightened, too.

"I had better do something at once to make Wolf afraid."

So thinking, Deer threw back his head and opened his mouth, and laughed as loud as he could. Now that was the worst thing the Deer could possibly have done, because it gave Wolf his first opportunity to look into his mouth. Imagine Wolf's surprise to see such small, flat teeth! Of course they were made that way for chewing grass and roots, but Wolf had always imagined Deer must have big, sharp, strong teeth like the great brown bear to keep himself so fat and sleek. It was a revelation indeed, and likewise the downfall of Deer, for the Wolf, as soon as he saw the Deer did not have sharp, pointed teeth, was no longer afraid of him. In a flash he jumped upon him and tore him to pieces.

In the meantime Raven had flown off to his nest to gloat

85

over the treasure he had tucked beneath his wing. He called together some of his friends and related to them how he had tricked Deer.

"Was I not smart," he bragged, "to fool so large an animal?"

You may be surprised to hear that even as he was telling his story, his friends were plotting how to steal the combs away from him. Had he not stolen them from someone else? Suddenly he guessed what the others were thinking, for quick as a flash he stuffed one of the combs into his mouth and swallowed it, and the other he hurled far out over the edge of the cliff, where it lighted on a spruce tree way down in the forest below. Today you will see it in the form of pitch clinging to the side of spruce and other needle trees. Thus Raven gave half the booty he stole to the trees to keep his friends from stealing it from him.

All this while Fox was hiding in the bushes near-by, and had seen and heard everything that happened.

"What a splendid idea," he thought, "to steal what you need from others. I shall no longer work for the food I need. I shall sleep all day, and go out at night and steal it instead."

And that is how Raven's treachery made a sly thief out of honest, hard-working Fox.

Fox was anxious to know if stealing was as easy as it seemed, so he hurried away to where he knew a mother bird was sitting on a nest of little ones. When he arrived there, the old bird was feeding her fledglings.

"I have a wonderful story to tell you," Fox called to her. "Put your head under your wing, and turn your ear this way, so you can hear me better."

The mother bird, who liked and trusted Fox, did as she was told. But as Fox was telling the story, he was biting off the heads of the baby birds, one by one, and putting the birds in his bag. By the time the story was finished, he had killed them all, and he hurried off, leaving mother bird still sitting there with her head under her wing.

Moral: A dishonest deed is as contagious to others as a loathsome disease.

The Worm Legend

This is an excellent example of a legend with a specific moral precept. I have heard it told many times at public gatherings and in testimonies at church to call attention to great catastrophes that can come out of a simple act of disobedience. It was related to me by blind Grotan, the legend authority among the natives of Klawock. Grotan was in his fifties, but still the strong man of the village. Although blind since birth, in his early twenties he was known to row distances of up to forty miles at one stretch, an incredible feat. My hunting partner, Henry Murphy, and I rowed a distance of twenty-six miles in fifteen hours one day, stopping only long enough to cook two meals over a fire. The trip nearly exhausted me.

I went down to Grotan's cabin one morning for the specific purpose of getting him to tell me this legend. When I arrived I found him working over his gas boat motor which he had strewn out all over the floor. He welcomed me but asked that I not move any of the engine parts. I was fascinated by the man's self reliance and courage in spite of his handicap.

Before Grotan began the legend he asked me whether I could lift his rock, an immense boulder which he had transported in his gas boat from Shinakoo Creek for the Indian men to test their strength upon. The rock was almost round and weighed, it was said, about five hundred pounds. It was the shape of the boulder that made it hard to lift. When I saw it I knew that I could not budge it so I did not try. Grotan laughed and said in broken English: "I still lift him."

This blind story-teller told the legend in Tlingit. There were parts of it I could not understand, so I had to call in a passerby now and then to get the interpretation.

During the winters of the olden days, when the Tlingit nation was at the height of its power, the people lived together by hundreds in huge community houses. To construct such a house, they first dug an enormous, deep hole in the earth. Then they built terraces, one above another, all the way to the top, and roofed the big pit with logs to protect it from the weather. The families occupied the terraces according to their rating in the tribe. Each family had its own private nook, screened by hanging blankets.

Great quantities of wood were needed to keep such a large house warm and comfortable during the bitter cold of the long winter. The men cut the wood out in the forest and all the women and children turned out to form a passing line from the wood pile to the house, for the Tlingits believed, as we do, that "many hands make light work."

It was on a wood gathering day such as this that one of the small girls of the village noticed a little white grub worm in some rotten wood near where the men had been cutting. It was so pretty and white that she wrapped it up carefully in a thimble berry leaf and took it home with her. Her parents knew nothing about their daughter's attachment to this tiny grub worm, for it was a very insignificant little worm and an innocent enough pet. The girl kept it under her pillow for a long time, taking it out each day to feed it with fish-oil, which she took from the wooden box where it was stored. The worm grew rapidly with such tender care, and it became obvious to the little girl that if she wanted to keep her pet hidden, she would have to make a cabin of her own in which to hide it. This she did, under pretext of wanting a private place to weave her baskets and rugs, at which she was adept. Her problem was solved, so she thought, but the worm grew bigger and bigger and as it grew it became huingrier and hungrier. She had to steal oil from the provisions of others so as not to be discovered by her own parents. As the worm grew it became more and more understanding of its mistress, and of the songs she sang to it before she took her leave each day.

Finally she decided to nurse the worm at her breast as she

would a baby of her own. Was this not her baby, and was not she responsible for its becoming so large and knowing? She would never desert it now. Suckled by a human breast, the worm gained rapidly in proportions and began to take on human features. It developed human eyes and a big head with large gopher-like jaws, whose cheeks hung like pockets on either side of its little round mouth, and its human mother thought it very handsome.

The tie between them grew and grew until the girl found it extremely difficult to take leave of the worm, even to perform her daily tasks. The only way she could appease it was to sing, and then her parents asked her why she sang so much. She sang because her heart was glad, she told them, to quiet their suspicions.

Finally, the worm became so large it filled the whole room. Then the girl began to dig a hole beneath her hut, and when it was big enough to hold the body of the worm, she pushed it in, leaving just the head outside in the room. The worm seemed to suffer no ill effects from his earth bound body, for after all he was a worm. Several months passed without any mishaps either to the worm or to the girl.

The villagers, however, were becoming suspicious about the disappearance of an unusual amount of food from the village store. They began to suspect the girl, but surely she could not be eating all of it herself! Her parents had noticed that their daughter seldom left her own room, and they still were curious about her singing so much. They began to watch her very closely. One day the girl went foraging for her worm and when they saw her leave the house, they both ran quickly to her cabin to look around. The sight they saw there frightened them both, for glaring at them with goggling eyes, was the head and face of the worm now grown to immense proportions. They hurried away, knowing that their daughter would soon return, and began at once to make their plans. They told the old chief what they had discovered and, with his assistance, they arranged a way to get the girl out of the neighborhood, so they might have the monster killed.

89

As the girl was one of the best basket and rug makers in the tribe, they decided to ask her to go to a village just across the bay to display her work. At first the girl protested violently, for she had a premonition that all was not going to be well with her pet. Who would feed it and give it drink in her absence? Lest her grief arouse the suspicion of her mother and father, she finally consented to go away for a short period. The date of departure had been set for the very next day.

All that night she sat up and explained to the worm by song why she was leaving, asking that it be patient in her absence, and promising to return just as soon as she was able. She had sung her going away song many times, but her absences before had been brief, and so that the worm would understand that this time she would be gone for several days, she sang her song again and again.

Finally the sun came up over the mountain and its feeble rays fell upon the bed she had not slept in at all. Someone knocked upon her door, and with tears in her eyes she sang the song of farewell for the last time, for something told her that she would never sing it again. The Indian maid began to dress herself for the journey. She put on her woolen skirt made of fine goat's hair from British Columbia. It was heavy with copper spangles which sparkled in the light like the jewels of an oriental queen. Her blouse was of Spanish silk, which her father had bought from a white man who owned a sailing vessel. She draped a beautiful, costly blanket about her shoulders. It was of navy blue wool with the tribal insignia worked upon it in red flannel. The figures of the animals and birds were outlined with pearl buttons made from abalone shell. After taking one more look at the pampered worm she went to her breakfast of jerked venison and Hudson Bay tea which grew in abundance in the muskegs. Then her uncle put her into a canoe, and soon she was on her way across the bay.

Almost immediately the warriors of the tribe took sharp spears which they had prepared and went into the hut. There was the hideous face of the monster worm, but had the warriors any idea of its immensity, they would never have tried

to destroy it. After a few directions to his men the chief sank the shaft of his spear deep into the worm's head. The worm retracted in agony. The other men followed suit while the worm writhed in pain. As it turned in its earth tunnel, the ground upon which the town was built began to move. The rocks cracked open, and the giant trees began to fall upon the village and demolish the houses. There was such pandemonium and shrieking of women and children that the girl heard it way out upon the waters of the bay. She knew what was happening, and began to sing her love song to the dying worm. She would have drowned herself had not the men in the canoe held her in the boat by sheer force.

The death throes of the worm destroyed the entire village. The worm liberated itself from its earth tunnel and rolled into the ocean and was drowned. Even to this very day you can see the upheaval caused by the giant worm in the vicinity of Hole-in-the-Wall. The memories of this event have been handed down from generation to generation in song and legend by the Tlingit people. This story is always referred to by the older men of the village when they wish to counsel their children, to give them an example of how much trouble can come from the simple act of befriending even a small grub worm, if done without the knowledge and consent of their parents.

Skagah, the Pirate

Skagah was the actual name of an Indian buccaneer who pillaged and plundered native settlements of the Pacific Northwest. Skagah was a Haida. The Haidas like the Tlingits belong to the same physical type as other American Indians, though they differ in language. The Haida Indians occupy a compact geographical area adjacent to and south of the domain of the Tlingits. They comprise the Kaigani of Prince of Wales Island and the north coast of Queen Charlotte Islands; the Klu, Kiddan, Nistence, Skidagate, Skid-a-gatee, Com-she-was, and Chut-sin-ni of Queen Charlotte Islands.

The Haidas and the Tlingits were perpetually at war in the olden days. Today friendly commercial competition exists between them, and competition in the form of athletic tournaments is popular among the young.

This was one of the legends told to me by the elderly Mrs. Kookash Brandon. It is the Tlingit version of how Skagah met his death.

Between the years of 1860 and 1877 there flourished a dreaded buccaneer among the Indian tribes of southeastern Alaska. The name of Skagah caused the hearts of the stoutest and strongest warriors to quake with fear. Mothers frightened disobedient children into submission by the use of this name. Skagah was a Haida. He was tall and muscular and had a voice that boomed like the ocean on a reef. Although he made it a point not to endanger his own life unnecessarily, he incited his men to sheer recklessness. For booty he looted any village that he thought might prove lucrative in food, fish, furs and women. He made slaves of the men he did not kill and claimed the women for his own. Skagah was successful in plying his trade.

Iron was known to the natives who inhabited the coast of Alaska long before the white man introduced it, but stone tools and weapons were most common. The natives did not refine the ore themselves but obtained what little iron they possessed from parts of barrels, boxes, and wrecks of ships which washed up on their shores. The natives could tell which contained iron by the sound they made while pounding on the shore. Finding a piece of iron, even if only a nail, made some lucky one rich, and there was great rejoicing because of it. A maid wearing a nail dangling from a thong about her neck had a dowry for which any young brave would risk his skin. Nails were used to make tips for arrows, augers and knife blades. Anyone so fortunate as to possess the smallest blade could trade this knife for several slaves. It was over a knife like this that the brutal Skagah came to his end.

The young Tlingit warrior, Kookash, had such a knife. Now Kookash, like young men of all nations, wished to take for himself a wife. Although he loved his knife dearly and carried it in a rawhide sheath at his side so that it would always be close to him, he decided one day that three slaves in marriage would be of more practical value to him than a knife. Who knows but his betrothed was responsible for this keen insight? Thereupon he started south with some companions one rainy morning to the country of the dreaded Haidas. Three

days and two nights they walked through the rain and wind. On the third night when Kookash was out gathering wood near the shore his keen ear detected a branch crack some yards to the left of him. A bear, thought he at first, but the wind was blowing toward him and surely the odor which it bore was not that of a bear. Rather, it savored of seal oil, the oil with which warriors anointed themselves to stave off the cold and the wind. With his natural cunning he acted as if he had heard nothing and went on about his task. For his patience he was rewarded at last by hearing whispers, and the name of all names was borne to his ears . . . Skagah! His heart stopped beating for a moment and his blood froze in his veins—but for just a moment—then his temples waxed hot and he was taut for action. He clutched the blade at his side, his only outward show of emotion. Meanwhile, he continued to gather wood so as not to make his alarm known.

Kookash understood some Haida, just enough to learn the plans of his enemies. When he met his companions again he told them of Skagah's intended attack for that very night. Kookash and his companions had had no sleep since they had started their journey and they could hardly keep their eyes open. As Kookash was stronger than the rest and the only one who had a knife, it was decided that he should watch while the others slept. Kookash clutched his knife and faced the beach standing upright so as to be sure not to fall asleep.

One hour, two hours, he stood thus and nothing occurred. He prayed to the wolf and the bear that the night would see him through unmolested. Then Kookash fell asleep, just for an instant, but that instant was too long a time. He awoke and his arms were pinned from behind and someone had him by the hair so he could not move. It seemed to him like ages that he was in this deplorable plight. At last the hands left his ears and he heard the booming voice of Skagah:

"Hold him until I get there. His companions are dead!"

In the darkness, with panic in his heart, Kookash unmistakably felt something hard and cold under his foot. He explored it with his toes. Could it be . . . yes, he was sure . . . it

was his knife! It had become dislodged in the struggle. Cautiously he grasped it between his toes. Stealthily he raised it to his right hand. His arm was still pinned at the elbow from behind. Now he clutched the hard metal blade in his hand. Skagah drew nearer and nearer until they were face to face at last. It was time for Kookash to act and with an upward surge he thrust the knife home to the hilt in the pirate's belly.

Have you heard the roar of the Skookum Church (Great Falls) in the spring when the ice begins to melt? Such was the roar that came from the throat of Skagah, the pirate. At this mighty blast the captors released their hold in amazement. Instantly Kookash escaped into the night. Fast as a hunted deer he fled to the north country from whence he had come. Someone shot an arrow in his direction and its point pierced his shoulder. It stung like a thorn wound and burned like a fire. It knocked Kookash down but he was up like a flash and on his way again. This time he escaped altogether. It was hours afterward that he realized that the blade from his knife was gone. He had broken it off in the stomach of Skagah.

Later he received news that confirmed his loss. Skagah had wasted away and died. In the ashes of his cremated body was found the knife of Kookash.

Two other publications by the author:

Price: $5
64 pages 8 1/2 x 11

Price: $8
116 pages 8 1/2 x 11

Order these now from the author. Books are to be prepaid but shipping and handling is free.

Order from: Nan Kaiper Slygh
738 Clinton Place
River Forest, Illinois 60305